euan macdonald (everythinghappensatonce)

Texts by

Barbara Fischer

Ann MacDonald

Lisa Gabrielle Mark

Midori Matsui

Giorgio Verzotti

 Verlag für moderne Kunst Nürnberg

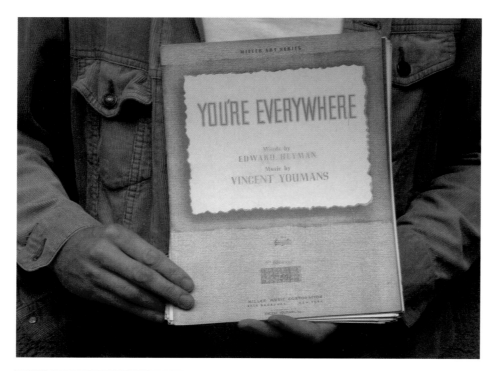

- Where Flamingos Fly 2005
 Production photographs
 Single-channel video projection
 10 minutes

There are many people whose expertise and generosity made this book possible. First, I must thank the Verlag für moderne Kunst Nürnberg and Manfred Rothenberger for their kind offer to publish a book on my work, as well as Martina Buder and Annette Scherer, who assisted with coordination and production. I also thank Barbara Fischer and Ann MacDonald for curating my exhibition *Two Places at Once*. I am grateful to my galleries, who enabled the publication of this book in addition to loyally championing my work over the years: Cohan and Leslie, New York; Galleria S.A.L.E.S., Rome; Jack Hanley Gallery, San Francisco; Darren Knight Gallery, Sydney; Tracey Lawrence Gallery, Vancouver; Birch Libralato, Toronto; James Van Damme/BRUSPRINGS bvba, Brussels; and Galerie Zink & Gegner, Munich. I am also grateful for continued support from Vanessa Ohlraun, cultural attaché at the Canadian embassy in Berlin. Special appreciation goes to Salah J. Bachir for generously supporting this book.

I extend my gratitude to the many individuals who contributed their skills to this publication. With her characteristic patience and artistry, Hilja Keading helped me produce and edit many of the video works of the last five years that are reproduced here. Barbara Fischer, Ann MacDonald, Midori Matsui, and Giorgio Verzotti all contributed insightful texts. Jane Hyun lent her exceptional copy-editing abilities to the project, while Marguerite Shore, Elisabeth Pozzi-Thanner, and Bernhard Geyer assisted with the German and Italian translation of texts. In addition to contributing a foreword, Lisa Gabrielle Mark acted as consulting editor. Her long–standing familiarity with my work, as well as her many years of experience in the field of writing and publishing, kept this book on the right track. Finally, I thank Willem Henri Lucas for organizing my disorganization and expertly designing this publication.

Euan Macdonald

Dieses Buch verdankt sein Entstehen dem Fachwissen und der Großzügigkeit vieler Menschen. Vor allem möchte ich dem Verlag für moderne Kunst Nürnberg und Manfred Rothenberger für das freundliche Angebot danken, ein Buch über meine Arbeit zu publizieren. Martina Buder und Annette Scherer danke ich für die Hilfe in Koordinierungs- und Produktionsangelegenheiten. Ebenso danke ich Barbara Fischer und Ann MacDonald für die Kuratierung meiner Ausstellung *Two Places at Once*. Den Galerien, die meine Arbeiten vertreten, bin ich nicht nur dankbar, dass sie die Herausgabe dieses Buches unterstützten, sondern auch dass sie sich über Jahre hinweg so loyal für meine Arbeit einsetzen: Cohan and Leslie in New York; Galleria S.A.L.E.S. in Rom; Jack Hanley Gallery in San Francisco; Darren Knight Gallery in Sydney; Tracey Lawrence Gallery in Vancouver; Birch Libralato in Toronto; James Van Damme/BRUSPRINGS bvba in Brüssel und Galerie Zink & Gegner in München. Mein Dank geht an Vanessa Ohlraun, Kulturattaché an der Kanadischen Botschaft in Berlin, für ihre anhaltende Hilfestellung. Besonders dankbar bin ich Salah J. Bachir für die grosszügige Unterstützung dieses Buches.

Mein Dank geht auch an alle, die mit ihrem Fachwissen einen Beitrag zum Entstehen dieses Buches geleistet haben. Mit der ihr eigenen Geduld und Kunstfertigkeit half Hilja Keading in den vergangenen 5 Jahren viele der im Buch aufscheinenden Video-Arbeiten zu produzieren und zu schneiden. Von Barbara Fischer, Ann MacDonald, Midori Matsui und Giorgio Verzotti kamen die wichtigen und einfühlsamen Texte. Jane Hyun war mit ihrem außerordentlichen Redigiertalent zur Stelle. Marguerite Shore, Elisabeth Pozzi-Thanner und Bernhard Geyer halfen bei der Übersetzung der italienischen und englischen Texte. Lisa Gabrielle Mark steuerte nicht nur das Vorwort bei, sondern war auch ein wichtiger beratender Lektor. Ihre Vertrautheit mit meinem Werk und ihre Erfahrung mit Autoren und dem Verlagswesen ermöglichten es, die notwendige Übersicht zu bewahren. Schließlich möchte ich Willem Henri Lucas dafür danken, dass er meine Desorganisation so gut geordnet und diese Publikation so meisterhaft gestaltet hat.

Aus dem Englischen übersetzt von Elisabeth Pozzi-Thanner.

This book is published in conjunction with the exhibition
"Two Places at Once," curated by Barbara Fischer and
Ann MacDonald and organized by the Blackwood Gallery,
University of Toronto at Mississauga, and the Doris
McCarthy Gallery, University of Toronto at Scarborough,
with the support of the Ontario Arts Council. Additional
support was provided by the Canada Council for the Arts;
Toronto Arts Council; Foreign Affairs Canada through
the Canadian Embassy, Berlin; as well as the Kenderdine
Art Gallery, Saskatchewan; Art Gallery of Windsor; Luckman
Gallery, California State Los Angeles; Salah J. Bachir;
Birch Libralato, Toronto; BRUSPRINGS bvba, Brussels;
Cohan and Leslie, New York; Darren Knight Gallery,
Sydney; Galleria S.A.L.E.S., Rome; Tracey Lawrence Gallery,
Vancouver; and Galerie Zink & Gegner, Munich.

Consulting Editor: Lisa Gabrielle Mark
Copy Editor: Jane Hyun
Designer: Willem Henri Lucas
Printer: Druckerei zu Altenburg, Germany

© 2005 Verlag für moderne Kunst Nürnberg

ISBN 3-938821-00-0
Printed and bound in Germany

Bibliographic information published by Die Deutsche
Bibliothek. Die Deutsche Bibliothek lists this publication
in the Deutsche Nationalbibliografie; detailed bibliographic
data is available on the Internet at http://dnb.ddb.de.

Front Cover: Untitled with Snow 2005
 Single-channel video projection
 7 minutes

Back Cover: GAD 2004
 Single-channel video projection
 1 minute

Front Endsheets: Untitled (truck and shadow) 1997
 Ink on paper
 76 x 51 cm

Back Endsheets: Untitled (shadow) 1997
 Ink on paper
 76 x 51 cm

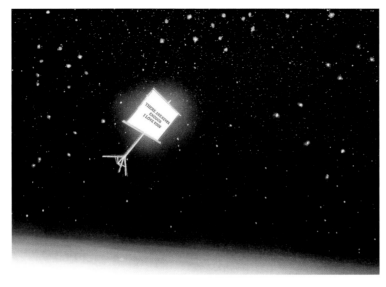

- Satellite (detail) 2005
 Gouache on paper
 101,5 x 76 cm

CONTENTS / INHALT

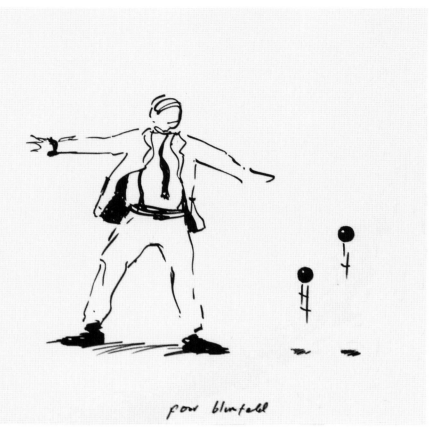

- Poor Blumfeld 2003
 Ink on paper
 75 x 50 cm

everywherehappensatonce: the problem of context for the "globalized" artist

Überallgleichzeitig: Kontext als Problemstellung für einen „globalisierten" Künstler

Lisa Gabrielle Mark

For Euan Macdonald, the question "Where are you from?" is invariably fraught. Born in Edinburgh, Scotland, and schooled in the midlands of England, Macdonald moved to Edmonton, Canada, in 1979 and then to Toronto in 1984 to attend art school. He began his career as an artist in Toronto, where he continues to show actively, and eventually made his way to Southern California. In 2004, when Macdonald represented the United Kingdom at the Seville Bienal along with Tracey Emin, organizers were understandably confused about his national identity. Curator Harald Szeemann helpfully reminded them of the realities of global culture—a concept he helped popularize—and in doing so (surely consciously) undermined the whole notion of national representation. Like the many peripatetic artists who orbit within Szeemann's "global culture," Macdonald maintains an exhibition schedule that regularly takes him to destinations in Australia, Canada, Europe, and the United States.

Die Frage nach seiner Herkunft hat bei Euan Macdonald immer einen großen Stellenwert. Geboren in Edinburgh, der Hauptstadt Schottlands, und erzogen in den englischen Midlands, zog Macdonald 1979 nach Edmonton, Kanada, und 1984 weiter nach Toronto, wo er eine Kunstschule besuchte. Er begann seine Künstlerkarriere in Toronto, einer Stadt, in der er weiterhin gerne ausstellt, und lebt derzeit im Süden Kaliforniens.

Als Macdonald im Jahr 2004 bei der Biennale in Sevilla, zusammen mit Tracey Emin, Großbritannien vertrat, waren die Veranstalter verständlicherweise über seine nationale Identität verwirrt. Der Kurator Harald Szeemann sprang hilfreich ein. Er verwies auf die Gegebenheiten globaler Kultur – ein Konzept, das mit seiner Unterstützung bekannt wurde – und unterminierte damit (sicher bewusst) den Begriff „Ländervertretung". Macdonalds Ausstellungskalender bringt ihn, wie so

viele andere peripatetische Künstler, die sich innerhalb Szeemanns „Globalkultur" bewegen, regelmäßig nach Australien, Kanada, nach Europa und in die Vereinigten Staaten.

Obwohl an der Wende zum 21. Jahrhundert so viel über den Begriff „Globalisierung" nachgedacht und diskutiert wurde, geht man in der Welt der Kunst weiterhin vom heimatlichen Standort des Künstlers als wesentlichem Markstein aus. Egal, ob das jetzt ein Kunsthändler ist, der potentielle Kunstsammler ködern möchte, ein forschender Kunsthistoriker oder ein Museumskomitee, das sich um ein ausgewogenes Gleichgewicht bei seinen Kunst-Ankäufen bemüht. In Los Angeles, wo Macdonald derzeit lebt, nimmt man von Künstlern üblicherweise an, dass sie eine der vielen bekannten Kunstakademien besucht haben, oder bringt sie mit der langen Reihe von Künstlern in Zusammen-

Though a great deal of rhetoric was spent on the notion of globalization at the turn of the twenty-first century, the art world continues to rely on place as an important marker for an artist's practice—whether it be a dealer attempting to lure potential collectors, an art historian engaged in research, or a museum acquisitions committee looking to balance its collection. In Los Angeles, where Macdonald is currently based, artists are usually presumed to have attended one of the city's many renowned art schools or are contextualized via the lineage of important figures that emerged from or settled there. To be otherwise is to risk a kind of "brand confusion."

Since Szeemann's landmark exhibition "Plateau of Humankind" for the 2001 Venice Biennale, the resilience of curatorial concepts such as the globalization of art has been tested by the marketplace as well as academic and cultural institutions. However, the reality for many artists remains that being

hang, die von dort stammen oder sich dort angesiedelt haben. Wenn man anders ist, riskiert man so etwas wie „Konfusion des Markennamens".

Seit Szeemanns grundlegender Ausstellung „Plateau of Humankind" im Jahr 2001 auf der Biennale in Venedig haben der Kunstmarkt sowie akademische und kulturelle Institutionen begonnen, die Elastizität kuratorialer Konzepte, wie zum Beispiel die Globalisierung der Kunst, auf die Probe zu stellen. Weiterhin werden aber viele weltweit anerkannte Künstler von den lokalen Gruppierungen, in deren Mitte sie zufällig arbeiten, an die Peripherie verbannt: Damit werden diese, mit allen Vor- und Nachteilen, für immer zu Außenseitern. Macdonald nützt diesen Außenseiter-Status so weit wie möglich aus, der ihm die Freiheit gibt, Themen aufzugreifen, die von anderen übersehen werden. Er kann vermeiden, sich auf einen einzigen überall erkennbaren Stil festlegen zu müssen, und kann sich einer weiten Palette von Medien, wie Zeichnung, Malerei, Skulptur und Video, bedienen. Obwohl seine Kunstausbildung ihn in keiner speziellen Ästhetik oder theoretischen Tradition positioniert, gleicht er dies in seinen Arbeiten ständig aus, indem er konsequent bekannte Themen und Ideen neu aufgreift und sie ganz bewusst mit Humor und politischer Kritik unterlegt.

The World (2003) zum Beispiel, ist ein maßstabgetreues Abbild des gleichnamigen Luxusdampfers, auf dem sich Eigentumswohnungen für reiche Leute befinden, die ihre Zeit damit verbringen, von Hafen zu Hafen zu segeln. Eigentumswohnungen, die auf dem Schiff nicht verkauft werden konnten, wurden als temporäre Kreuzfahrts-Unterkünfte verkauft. Im gleichen Zeitraum, den eine solche Luxuskreuzfahrt dauern würde, schuf Macdonald in seinem Studio *The World*. Er stellte

globally identified means being relegated to the periphery of whatever community one happens to work within; it means, for better or worse, being forever an outsider. Macdonald makes the most of the freedom afforded by that status—allowing himself to pursue overlooked subject matter, eschewing a recognizable style, and producing work in a range of media that includes drawing, painting, sculpture, and video. Although his formal training does not situate him within any particular aesthetic or theoretical tradition, his work compensates by consistently revisiting certain themes and ideas in a manner that is consciously underplayed for humor and subtle political critique.

For instance, *The World* (2003) is a scale model of the cruise ship bearing the same name that contains condominiums the wealthy could buy so as to spend their days floating from port to port. The condos that failed to sell were sold as temporary cruise accommodations. Made by Macdonald in his

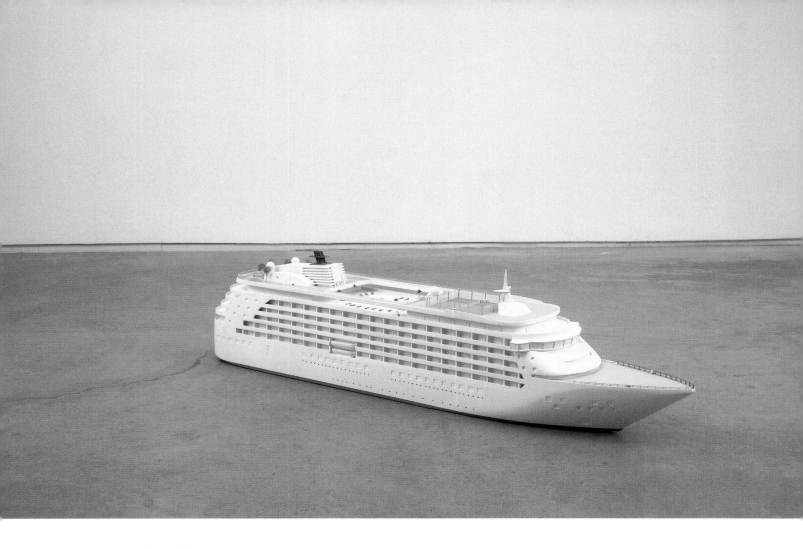

- The World 2003
 Wood and mixed materials
 122 x 23,4 x 23 cm

- The World (detail of swimming pool) 2003

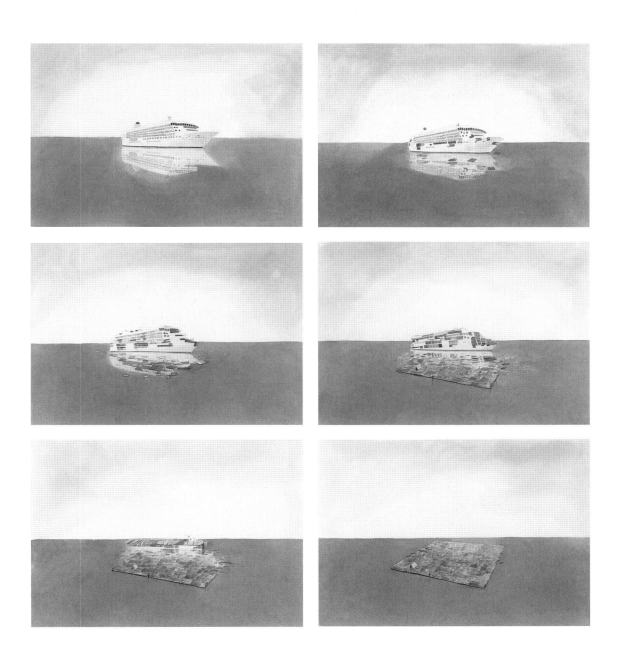

- Untitled (The World) 2003
 Ink on paper
 50 x 38 cm each

Zeit und Arbeits-Zeit einander gegenüber und machte die damit verbundene Sozialkritik deutlich, ohne all zu didaktisch zu wirken. Nicht nur die konzeptuellen Akzente dieser Arbeit können wir schätzen, sondern gleichzeitig auch einen Blick auf den Lebensstil der „High Societies" werfen.

Macdonalds Arbeiten sind oft von einem untertriebenen, wenn nicht sogar „amateurhaften" Zugang zu Methoden und Ästhetik gekennzeichnet. Er stülpt die etablierten Ordnungen ganz einfach um. Oft interessieren Macdonald Bilder und Szenen, die andere Künstler einer artistischen Darstellung für unwürdig erachten. Oder er fängt Momente ein, die für andere zu flüchtig oder zufällig sind, als dass ihnen anhaltende Aufmerksamkeit gebührt. Im Video *Where Flamingos Fly* (2005) spürt man die freudige Offenheit, mit denen Fremde auf ihnen neue Orte zugehen, während

dieselben Plätze für ständige Bewohner ganz selbstverständlich und fast langweilig sind. Macdonald, dessen Gesicht die Kamera ausgespart hat, hält in diesem Video einen Stapel Musiknoten aufrecht gegen seine Brust gelehnt, so dass wir die Titel lesen können. Während wir im Hintergrund Musik hören, legt er ein oberstes Blatt nach dem anderen zur Seite, ähnlich wie es Bob Dylan in der legendären Szene des Films *Don't Look Back* tut (1967), durch Karten schnippt, auf denen der Text des *Subterranean Homesick Blues* geschrieben steht. Die Musik zu *Where Flamingos Fly* ist ein Potpourri der Musik auf den Notenblättern – jedes Lied ein Hinweis auf die im Film gezeigten Noten.

Macdonald fand die Noten und die Inspiration ganz zufällig in einem Ausverkaufs-Warenkorb eines Musikgeschäftes. Als er die Titel durchsah, formierten sie sich wie zufällig zu einer Geschichte: Jemand besucht zum

studio during the period it would take to complete such a cruise, *The World* pits "leisure" time against "labor" time such that the social critique is self-evident without being overly didactic. Moreover, in addition to appreciating the conceptual underpinnings of the piece, we're still allowed a look into the "lifestyles of the rich and famous."

Macdonald's work is often marked by an understated, if not "amateurish," approach to technique and aesthetics, as well as an inversion in the established order of things. He is frequently drawn to images and scenarios that others might deem unworthy of representation—moments too fleeting or contingent to bear sustained consideration, objects too apparently unimportant. The single-channel video *Where Flamingos Fly* (2005) is marked by the openness that foreigners bring to new places, reveling in things denizens might take for granted. Macdonald, whose face is out of frame, holds a stack of sheet music

ersten Mal eine Stadt, verliebt sich und hört schluss-endlich auch wieder auf, verliebt zu sein. Macdonald verfeinerte den Bogen dieser Geschichte, indem er die vorgefundene Sequenz der Blätter leicht veränder-te. Das berauschende Gefühl der Neuheit, das der Fremde verspürt, wird zum berauschenden Gefühl des Verliebtseins:

> Neu in der Stadt – Kaffeepause
>
> Das freundlichste Ding
>
> Eine neue Sonne am Himmel, schön und gut
>
> Liebe ist wunderbar, überall
>
> Meine stille Liebe, sanft wie der Frühling.

Man wird immer wieder daran erinnert, dass das Wort „Amateur" von „amare", von „lieben", kommt und eine Art Liebenden beschreibt. Jemanden, der etwas aus reiner Freude tut. In Macdonalds Arbeiten ist der Liebende/Fremde der „globalisierte" Künstler: Wenn der Ausgangspunkt unklar ist, sind Intention und Intensität umso wesentlicher.

Aus dem Englischen übersetzt von
Elisabeth Pozzi-Thanner.

upright against his chest with the title pages facing the camera. As the sound-track plays, he discards the top sheet in much the same manner as Bob Dylan in the legendary segment of the film *Don't Look Back* (1967), in which Dylan flipped through cards bearing the lyrics of *Subterranean Homesick Blues* as the song played. The musical component of *Where Flamingos Fly* is a medley of the songs seen in the sheet music—each song excerpt cued to each sheet in the video.

The sheet music is a kind of readymade Macdonald randomly discovered in a music-store sale bin. As he perused the titles, they seemed to suggest a narrative in which someone arrives in town for the first time and falls in and—eventually—out of love during the course of his or her visit. Macdonald then honed this story arc through some minor adjustments to the order of the sheets as they were found so that the exhilarating sense of newness experienced by the stranger is transformed into that of a lover:

new in town coffee time

the friendliest thing

new sun in the sky fine and dandy

love is wonderful ev'rywhere

my silent love soft as spring

One is reminded that the word "amateur" also denotes a kind of lover, someone who does something purely for the enjoyment of it. In Macdonald's work, the lover/stranger, then, becomes a stand-in for the "globalized" artist: when one's origins are obscure, intention—and intensity—are everything.

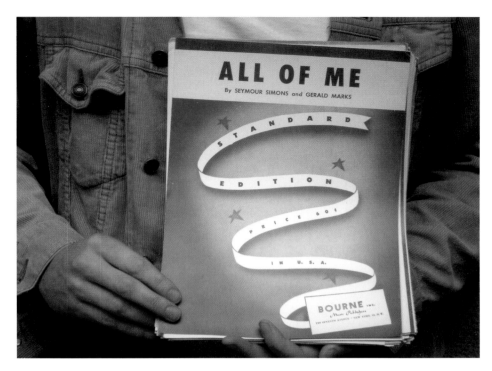

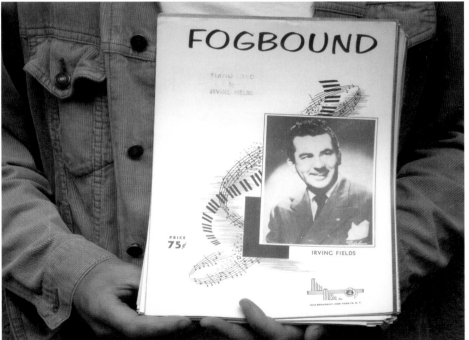

- Where Flamingos Fly 2005
 Production photographs
 Single-channel video projection
 10 minutes

- Poor Blumfeld 2003
 Two-channel video installation
 Installation view, Sculpture Center,
 Long Island City, New York, 2003

speed still or still speed

Schnelle Stille oder stille Schnelle

Barbara Fischer

In 1995, Milan Kundera observed in his novel *Slowness* that we seem to have lost pleasure in slowness. Signs of its return now appear everywhere. They abound in the general culture and certainly in the realm of art: entire magazine issues and exhibitions are dedicated to it, and there is a sudden embrace of relational aesthetics, of putting the duration of a lived moment, the sharing of a meal or convivial conversation, front and center.[1] It has been the mode of temporality, in manner and subject, for a panoply of installations, films, and video—lying down to gaze through a sheet of glass at a live barnyard with pigs doing their thing; watching for hours a film of a pasture of grazing cows; or looking at a photograph of a windy landscape, its turbulence and fluttering office papers frozen into a still, to mention just a few.[2] But, are such preoccupations (themselves strangely accelerated in the effective reach of contemporary means of communication) indeed signals of a return to a pleasure in slowness? Pushing further, in relation to what speed and/or what time, what place?

At first glance, much of Euan Macdonald's video work can be seen as slow—insofar as nothing much appears to happen (which, it seems, is one of the defining features of "slowness" at present). Sharing in the Minimalism of the late 1960s and Conceptual and Process art of the early 70s, includ-

Milan Kundera befand 1995 in seinem Roman *Slowness* (Die Langsamkeit), dass uns die Lust an der Langsamkeit abhanden gekommen war. Heute mehren sich die Anzeichen ihrer Rückkehr in allen Bereichen der Gesellschaft, speziell aber in der Kunst: Ganze Zeitschriften und Ausstellungen sind ihr gewidmet, und man begegnet immer häufiger einer relationalen Ästhetik, der nichts wichtiger ist als das Verstreichen eines gelebten Augenblicks, ein gemeinsames Mahl oder ein geselliges Gespräch.[1] Zahllose Installationen, Filme und Videos beschäftigen sich in Methode und Inhalt mit dem bedächtigen Zeittakt: Man legt sich hin und beobachtet durch eine Glaswand das Treiben in einem Schweinestall; man folgt stundenlang einem Film von Kühen auf der Weide; oder man betrachtet die Fotografie einer Landschaft, auf der das Wehen des Winds und das davonflatternde Büropapier zum Standbild erstarren. Die Beispiele ließen sich beliebig fortsetzen.[2] Aber sind diese Arbeiten (ihrerseits seltsam beschleunigt von der Allgegenwart der modernen Kommunikationsmittel) wirklich ein Indiz für die wieder gefundene Lust an der Langsamkeit? Und, genauer gefragt, im Vergleich zu welcher Geschwindigkeit und/oder welcher Zeit, welchem Ort?

Auf den ersten Blick kann ein guter Teil der Videoarbeiten von Euan Macdonald als langsam eingestuft

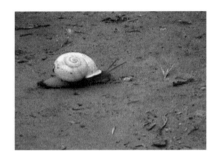

- Snail 2004
Single-channel video projection
5 minutes

ing aspects of "real-time" video, little action and quiet eventfulness are the norm in Macdonald's work. No giddy movement here: no tensing of the spectator's muscular attention to follow bumpy, blurry, hot-on-the heels documentary-camera action in pursuit of the Blair Witch or breaking news. Often consisting of what appears to be one irreducible take, Macdonald's work features a stationary camera that simply records a singular event unfolding in front of it. In *Snail* (2004), the screen is filled with a desert floor seen close up—nothing but rocks, some gravel, twigs, and a grassy stem here and there. Then, at the screen's left edge, there is a slight movement: a set of tentative feelers gradually emerge, followed by the head and finally the whole body of a snail with its "house" making an entry and passing ever so gradually, horizontally, to exit the right edge of the screen, at which point the video ends. The snail's journey—slow to our perception—qualifies the idea of the length of a "movie" and "development of narrative" to the time it literally takes a snail to pass through the frame set by the lens, and therefore across the screen.

As in certain conceptual video work, the frame imposed by the lens (and, in exhibition, the monitor or projection screen) marks the boundaries within which the whole of an event or action takes place. However, if earlier works tended to focus on the artist's own actions and subscribed to self-reference—think of Rita Myers crunching her body to fit within the frame of a camera slowly zooming in (*Slow Squeeze*, 1993), or early Bruce Nauman videos in which the camera lens (and the monitor) "contain" a shot of the studio walls against which the artist's various wall and floor positions take place, often acting out physically exhausting, existential Beckettian schemes—Macdonald consistently focuses his lens on casual moments and everyday events, whether found or staged. These may simply feature the particular movement of ordinary objects

werden, da in ihnen nicht viel zu geschehen scheint (offensichtlich ein entscheidendes Kriterium in der aktuellen Definition der „Langsamkeit"). Wie im Minimalismus der späten 1960er-Jahre und in der Konzept- oder Prozesskunst der frühen 1970er-Jahre, einschließlich Aspekten des Echtzeit-Videos, bevorzugt Macdonald ein Minimum an Handlung und einen stillen Ablauf des Geschehens. Es gibt keine Schwindel erregenden Bewegungen: Der Betrachter muss nicht mit verkrampften Muskeln verfolgen, wie die Dokumentarkamera in verwackelten, verschwommenen Bildern der Hexe von Blair oder den neuesten Nachrichten hinterherjagt. Macdonald verwendet eine feststehende Kamera, die häufig ein einziges vor ihr ablaufendes Ereignis aufzeichnet und sich dabei vielfach auf eine kontinuierliche, unveränderliche Einstellung beschränkt. In *Snail* (2004) füllt die Nahaufnahme eines Wüstenbodens den Bildschirm, nichts als Steine, Kies, Zweige und hier und dort ein Grashalm. Dann regt sich etwas am linken Rand: Fühler tasten sich vor, gefolgt von einem Kopf und schließlich dem Rest des Körpers einer Schnecke mitsamt „Haus". Sie kriecht gemächlich horizontal vorbei, bis sie am rechten Rand wieder verschwindet. An diesem Punkt endet das Video. Die Reise der Schnecke, die für unsere Augen langsam wirkt, rechtfertigt die Anpassung der Länge des „Films" und des „Handlungsablaufs" an den Zeitraum, den die Schnecke konkret benötigt, um das Blickfeld des Kameraobjektivs und damit den Bildschirm zu durchqueren.

Wie bei einer Variante von Konzeptvideos üblich, bestimmt der vom Objektiv (beziehungsweise in der Ausstellung vom Monitor oder von der Projektionsleinwand) gesetzte Rahmen die Grenzen, innerhalb deren sich ein Ereignis oder eine Handlung abspielt. Frühere Projekte konzentrierten sich jedoch gewöhnlich auf Aktionen des Künstlers und waren selbstreferenziell ausgerichtet – man erinnere sich zum Beispiel, wie Rita Myers ihren Körper verkrümmt hat, um ihn in den Rahmen einer langsam heranfahrenden Kamera hineinzuzwängen (*Slow Squeeze*, 1993), oder wie Bruce Nauman in frühen Videos mit dem Kameraobjektiv (und dem Monitor) ein Areal der Atelierwand „abgesteckt" hat, vor dem er sich in verschiedene Wand- und Bodenpositionen begab, oft strapaziöse, existenzielle Übungen im Stil Becketts. Macdonald rückt bevorzugt alltägliche Momente und belanglose Begebenheiten in den Brennpunkt, seien sie zufälliger oder geplanter Natur. Dabei handelt es sich entweder um die spezifische Bewegung eines unscheinbaren Objekts (Eiswagen, ein Ball auf einer Pfütze) oder um die Vorführung eines bestimmten Berufszweigs (Jodler, Bestattungsunternehmer, Heiler, Akkordeon-

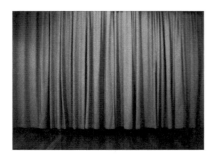

- Healer 2002
Single-channel video projection
5 minutes

(ice-cream trucks, a ball on a puddle) or a certain vernacular performance (a yodeler, a funeral director, a healer, an accordionist). In other words, instead of an event self-referentially describing a recording (submitting the body and one's action to the camera's registration if not its administration), Macdonald's moments are captured from the everyday and appear poignant, as if in quotation marks.

Macdonald's work shares Duchampian humor, especially when the movement at hand involves the anticipation of some great transformation to come. In *Healer* (2002), for instance, an elderly woman steps out on stage in front of the curtain to face the viewer, but a televangelical magic moment of healing never arrives as one waits and waits; the waiting itself becomes part of the event and, could we even speculate, suggests waiting as "healing"? Most certainly it impresses a sense of actuality, which, according to George Kubler, is "the interchronic pause when nothing is happening ... the void between events."[3] Alternatively, as nothing appears to be happening in Macdonald's works and the void extends into a seemingly interminable wait, nondescript situations can suddenly turn cosmic in proportion. In *Eclipse* (2000), he captures a ball bopping, seemingly forever, on the sun-reflecting surface of a puddle of water in the middle of a road. The wind moves the ball about until, unexpectedly and quite effectively, it eclipses the radiant reflection of the sun, noticeably darkening the screen.

More often, however, Macdonald's distant, seemingly uninvolved lens specifically mocks physical exertion and speed. In fact, rather than describing or unfolding slowness for its own sake, his work elaborates a silently resistant attitude toward the kinds of speeds that imply competition for the conquest of space, limitless expansion, or the drive to exceed physical limits. This attitude inevitably affects *doubleportraitofayodeler* (2003), the doubled performance of a yodeler who belts out vocal acro-

spieler). Anders formuliert, anstatt eines Ereignisses, das selbstreferenziell aufgezeichnet wird (die Unterwerfung des Körpers und seiner Handlungen unter das wachsame, wenn nicht gar überwachende Auge der Kamera), sind Macdonalds Momente dem Alltag abgewonnen und wirken pointiert, als wären sie in Anführungszeichen gesetzt.

Macdonalds Œuvre zeichnet sich durch einen duchampschen Sinn für Humor aus, speziell wenn die betreffende Aktion das Vorgefühl auf eine bevorstehende Verwandlung zum Inhalt hat. So tritt in *Healer* (2002) eine ältere Frau vor den Bühnenvorhang und blickt in den Zuschauerraum. Auf das magische Heilerlebnis wartet man jedoch vergebens. Das Warten selbst wird Teil des Geschehens, ja man könnte sogar spekulieren, dass es die im Titel angesprochene „Heilung" ist. Auf jeden Fall verstärkt es die Empfindung des Wirklichen, das George Kubler als „die dazwischenliegende Pause, wenn nichts geschieht ... das Nichts zwischen Ereignissen" bezeichnet hat.[3] Da es in Macdonalds Arbeiten offenbar keinen Handlungsablauf gibt und das Nichts sich zu einem Warten ohne absehbares Ende ausdehnt, können unbedeutende Situationen plötzlich kosmische Dimensionen annehmen. In *Eclipse* (2000) schaukelt ein Ball endlos lange, wie es scheint, auf einer im Sonnenlicht glänzenden Wasserpfütze in der Mitte der Straße. Der Wind spielt mit ihm, bis er überraschend und wirkungsvoll die Spiegelung der Sonnenscheibe überdeckt und der Bildschirm sich merklich verdunkelt.

Noch häufiger tritt jedoch der Fall ein, dass die distanzierte, vorgeblich unbeteiligte Linse Macdonalds ausdrücklich die Anstrengung und Hast des Körpers aufs Korn nimmt. Denn sein Werk begnügt sich nicht damit, die Langsamkeit um ihretwillen zu beschreiben oder ablaufen zu lassen, sondern es bezieht stille Opposition gegen jene Art der Geschwindigkeit, die einen Wettlauf um die Beherrschung des Raums, um eine Expansion ohne Ende oder um die Überwindung physischer

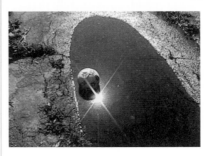

- Eclipse 2000
Single-channel video projection
2:25 minutes

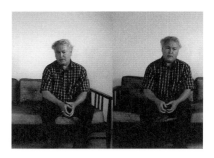

- doubleportraitofayodeler 2003
 Single-channel video projection
 1:25 minutes

batics that compete in a cacophony. When he stops, the "ain't it great?" effect is coupled instantly with a "now what?," much as in *Three Trucks* (2000), in which three ice-cream trucks from three different directions converge in a T-shape intersection one after the other. Blocking each other, none gives way or backs off, and all continue simultaneously to blare tunes that ring out in a noisy territorial stand-off. Here, the comedic attitude assumes a political subtext as the ice-cream trucks' advertising jingles lead to a dead-heat competition. Commentary is more overt in *The Weltmeister* (2004), in which an accordion player starts by performing the American national anthem; as he plays, his pace accelerates, and the anthem hurriedly morphs into an entirely different tune that races until the video's end. The accordion's brand—Weltmeister (German for "world master"), which is inscribed on the instrument— makes a sinister link between the performance of the American anthem, breakneck-speed entertain-ment, and "world" expansion.

Such direct hints are rare, however. Often oblique and implied rather than stated and literal-ized, the political attitude whereby all speedy ex-penditure becomes ironic is more often ecologically motivated, or rather focused on the "bigger" picture. *Brakestand* (1998), for instance, features a driver behind the wheel of a car with one foot apparently heavy on the gas pedal while the other is simultan-eously on the brake. The car's rear tires spin out of control, but the driver is unperturbed, catatonic even: his inertia in stark contrast to the speed that he causes or has in his power to utilize. His pos-ture is rather reminiscent of a commuter stuck in rush-hour traffic, burning time and bored at once. Like an automaton, he appears to have reached the final stage of what Marshall McLuhan described as the effects of stress, including those brought on by technological revolutions; alarm turns into resis-tance, which turns into boredom and indifference.

Grenzen impliziert. Diese Haltung prägt *doublepor-traitofayodeler* (2003), die verdoppelte Vorführung eines Jodlers, dessen Stimmakrobatik sich zu einer zweistimmigen Kakophonie verdichtet. Am Schluss der Darbietung folgt auf den Eindruck „War das nicht toll?" sofort die Frage „Was nun?". Dasselbe geschieht in *Three Trucks* (2000). Einer nach dem anderen aus verschiedenen Richtungen eintreffend, stoppen drei Eiswagen an einer T-förmigen Kreuzung. Sie versperren einander den Weg, keiner gibt nach oder weicht zurück, und alle plärren ihre Musik hinaus wie akustische Reviermarkierungen. In die komische Situation mischen sich politische Untertöne, als ein unerbittlicher Wett-kampf zwischen den Werbemelodien ausbricht. Noch unverhohlener ist der Kommentar im Video *The Welt-meister* (2004). Ein Akkordeonspieler spielt anfangs die amerikanische Nationalhymne, beschleunigt dann aber das Tempo und wechselt zu einem anderen Musik-stück über, durch das er bis zum Ende des Videos hetzt. Der auf dem Instrument lesbare Name des Herstellers („Weltmeister") zieht eine ominöse Verbindungslinie zwischen dem Abspielen der amerikanischen Hymne, der halsbrecherischen Unterhaltung und der Beherr-schung der Welt.

Solch direkte Stellungnahmen sind bei Macdonald allerdings selten. Die politische Position, die alle Hast und Unrast ins Ironische zieht, artikuliert sich eher angedeutet und indirekt als eindeutig und direkt und ist in den meisten Fällen ökologisch motiviert oder, präziser ausgedrückt, an größeren Zusammenhängen interessiert. *Brakestand* (1998) zeigt zum Beispiel einen Fahrer am Steuer seines Autos, der mit einem Fuß auf dem Gaspedal und mit dem anderen auf dem Brems-pedal steht. Obwohl sich die Hinterräder des Wagens wie wild durchdrehen, bleibt der Lenker gelassen, fast katatonisch. Seine Apathie steht in krassem Gegen-satz zur potenziellen Geschwindigkeit, die er erzeugt und verschwendet. Sein Verhalten erinnert an das eines Pendlers, der im Verkehrsstau steckt, sich lang-weilt und Zeit totschlägt. In seinem Roboter-Gehabe

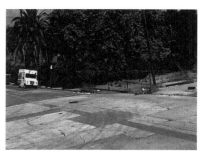

- Three Trucks 2000
 Single-channel video projection
 2 minutes

In *Brakestand*, this entropy of emotion appears to be the effect of speed. Giving new meaning to the idea of going nowhere really fast, the explosive expansion of the automobile, its speedy extension into space, is an image that describes expenditure spinning inevitably toward entropy. At the same time, it is compelling to see in the inertia of the driver, in his relation to the potential speed he causes, a description of another level of acceleration, one which distances us even further from realizing its ecological impact. Warning of the dangers of exhausting temporal and spatial distances due to the effects of remote control and instantaneous long-distance telepresence technologies, Paul Virilio saw the threat of a permanent inertia. As if describing *Brakestand*'s paradox between absolute standstill and extreme speed, Virilio queried when we would see "legal sanction, a speed limit, imposed not because of the probability of road accidents but because of the danger of exhausting temporal distances and so of the threat of inertia—in other words, of parking accidents."[4]

Finally and increasingly, however, Macdonald's concerns with the culture of speed and the degree of indifference with which the camera counters it has certain elegiac implications—a reach beyond the acculturated experience of time in the everyday, its forward drive, and the contemporary obsession with relinquishing time and distance by way of acceleration. For instance, the distinctly "amateur"-style video *SCLPTR* (2003) follows a pickup truck on a highway transporting a large sculpture of a smiling Buddha facing forward. The stillness and otherworldly dimension implied by the gaze of the sculpture and its symbolic meanings spread to the situation at hand: as the camera comes to pass the moving truck, it reveals the front license plate to read "SCLPTR1." Both the passing and the physical drive to transform matter become estranged in light of the Buddha's dictum "shed your desire." While elegiac, this is not to say that Macdonald's gaze is no longer ironic.

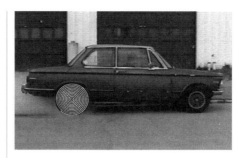

- Brakestand Reversal (with Duchamp Spiral) 2000
Black-and-white print
35,5 x 24 cm

scheint er die letzte Phase des von Marshall McLuhan beschriebenen Stresszustands erreicht zu haben, der unter anderem von technischen Neuerungen verursacht wird: Beunruhigung verwandelt sich in Widerstand und dieser in Langeweile und Gleichgültigkeit. In *Brakestand* scheint diese Entropie der Gefühle ein Resultat der Geschwindigkeit zu sein. Das Bild des explosiven Auseinanderstrebens des Automobils, seiner dynamischen Einwirkung auf den Raum, gibt der Wendung „schnell nirgendwo hinkommen" eine neue Bedeutung und suggeriert eine Verausgabung, die unaufhaltsam der Entropie entgegensteuert. Es lohnt sich, in diesem Zusammenhang die Teilnahmslosigkeit des Fahrers angesichts der von ihm verursachten Geschwindigkeit zu betrachten, die eine andere Ebene der Beschleunigung aufdeckt, und zwar eine, die uns noch weiter von der Erkenntnis *ihrer* ökologischen Auswirkungen entfernt. Paul Virilio hat vor dem Verschwinden zeitlicher und räumlicher Entfernungen durch den Einsatz von Fernsteuerungen und Bildübertragungstechnologien und vor der Gefahr einer daraus resultierenden permanenten Lethargie gewarnt. Als würde er das in *Brakestand* formulierte Paradox zwischen völligem Stillstand und Höchstgeschwindigkeit beschreiben, spielte Virilio mit der Möglichkeit eines „gesetzlichen Verbots, eines Tempolimits, das nicht wegen der Gefahr von Verkehrsunfällen eingeführt wird, sondern wegen der Gefahr, dass durch die Aufhebung zeitlicher Entfernungen die Apathie steigt – und damit das Risiko von Parkunfällen".[4]

In letzter Instanz gewinnt Macdonalds Beschäftigung mit dem Geschwindigkeitskult und mit dem Grad der Indifferenz der ihm entgegentretenden Kamera zunehmend elegische Beiklänge – seine Kunst weist hinaus über die Vorwärtsbewegung der Zeit, über ihre akkulturierte Erfahrung im Alltag und über den Drang der modernen Gesellschaft, Raum und Zeit durch Beschleunigung zu überwinden. So folgt das bewusst „amateurhafte" Video *SCLPTR* (2003) einem Lieferwagen auf

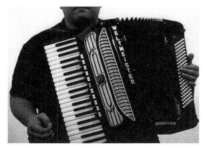

- The Weltmeister 2004
Single-channel video projection
2 minutes

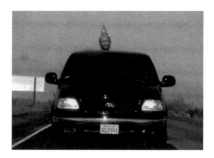

- SCLPTR 2003
Single-channel video projection
2 minutes

If we can invoke Robert Smithson here, "Eternal time is the result of skepticism, not belief."[5] Such is the case in *Interval* (1997). The impersonal nondescript setting belonging to no one in particular (common to other works by Macdonald that feature the desert, a blandly furnished apartment, or an empty office) here consists of the lanes of a commuter parkway that evoke the modern sprawl of Los Angeles, where the artist now lives. David James observed of a certain tradition in Los Angeles film and photo-based work: "no people and few cars, the city appears a ghost town of repetitive, suburban sprawl, without narrative or hierarchy... an endless façade of stucco buildings, palm trees, vacant lots, and gasoline stations, all without human presence, as if some dull apocalypse had turned it into an uninhabited twilight zone."[6] In *Interval*, cars zoom across the screen in both directions, occasionally slowing down to a stop (one presumes due to off-screen traffic lights). The long shadows of two slightly swaying palm trees work like a sequence of finish lines at various intervals, but the participating vehicles take no notice. What this work measures, ultimately, is what eludes drivers as individuals: driving at the tip of time's arrow may render their journey unique onto themselves, each caught in his or her own action plan and interests. But the shadows cast by the palms clasp each in other distinct durations, the existence of the trees over a certain time and the changing light caused by the earth's rotation around the sun.

The highway is the kind of space anthropologist Pascal Augé termed the "any-space-whatevers": anonymous, desingularized, and homogenous, caught in a limbo between destinations like Kubler's actuality as the continuous void between events. It is also the kind of bland and vapid space that Smithson saw in the interests of certain artists of his own generation and which he linked to the rise of a new consciousness where time as decay or biological evolution

der Autobahn, der eine große, lächelnde, nach vorne blickende Buddha-Skulptur transportiert. Die Stille und Transzendenz, die die Figur und ihr Symbolgehalt ausstrahlen, übertragen sich auf die dargestellte Situation: Als die Kamera den Lieferwagen überholt, wird die Aufschrift der vorderen Nummerntafel sichtbar – „SCLPTR1". Sowohl das Vorbeifahren als auch das physische Verlangen, die Materie zu transformieren, verlieren im Licht der Aufforderung Buddhas, das Begehren abzulegen, ihren gewohnten Sinn. Der Blick Macdonalds bleibt trotz aller Elegie ironisch.

„Die Skepsis und nicht der Glauben lässt die ewige Zeit entstehen."[5] Dieser Satz Robert Smithsons öffnet uns den Blick auf *Interval* (1997). Das anonyme, banale Ambiente, das allen und niemandem gehört (und in vielen Werken Macdonalds auftritt, sei es als Wüste, als abgeschmackt möbliertes Zimmer oder als leeres Büro), erscheint in diesem Video in Gestalt einer mehrspurigen Autobahn, Symbol des ungezügelten Wachstums der Stadt Los Angeles, wo der Künstler heute lebt. David James erkennt gewisse Gemeinsamkeiten im Werk dortiger Künstler, die mit Film- und Fotomaterial arbeiten: „Keine Passanten und wenige Autos, die Stadt als Geisterstadt der überall gleichen vorstädtischen Zersiedelung, ohne roten Faden oder Hierarchie ... ein Los Angeles, das aus endlosen Stuckfassaden, Palmen, Baulücken und Tankstellen besteht, ohne menschliche Präsenz, als hätte eine träge Apokalypse alles in ein unbewohntes Niemandsland verwandelt."[6] *Interval* zeigt Autos, die in beiden Richtungen über den Bildschirm fahren und bisweilen abbremsen und stehen bleiben (vermutlich vor Ampeln außerhalb des Bildfelds). Die langen Schatten zweier im Wind schaukelnder Palmen wirken wie in verschiedenen Abständen gezogene Ziellinien, die freilich von den Fahrzeugen ignoriert werden. Im Grunde misst das Video eben das, was den Fahrern entgeht: Mögen sie ihre Fortbewegung an der Spitze des Zeitpfeils und ihre Ziele und Interessen als noch so einzigartig empfinden, die Schatten der Palmen versetzen sie trotzdem wie

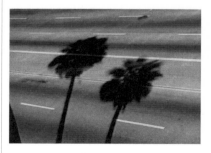

- Interval 1997
Single-channel video projection
2:25 minutes

was eliminated and immortality became a fact of emptiness.[7]

Opening up the psychological temporality (within which we are caught every day) to an experientially vaster duration, Macdonald's work loosens the hold of calendar and clock and warps our sense of time toward intimations of eternity, in which one's life is but a temporary flux among a multiplicity of fluxes. In *House (everythinghappensatonce)* (1999), the camera focuses on the entropic process in the form of a decrepit old boathouse perched across a waterway that is imperceptibly yet inexorably collapsing. In fact, its angle is so precarious one might be convinced that it is falling before one's eyes. Such slow motion, an eternity for the video's spectator, is suddenly interrupted by a racing speedboat. For the boat's passengers, the house is but a snapshot, an instant if even that, on their way to something else. In this single moment, there is a triplicity of simultaneous fluxes, to borrow the description from Gilles Deleuze: the movement of the house so slow it cannot be seen, the boat so fast it can hardly be noticed, or its passengers so quick that they can barely see the house in turn. Fast and slow are not only embodied in one and the same frame as two different, singular fluxes, but the spectator's duration also enters into the equation. "We call simultaneous then, two external fluxes that occupy the same duration because they hold each other in the duration of a third, our own ... [It is this] simultaneity of fluxes that brings us back to internal duration, to real duration."[8] The experience of duration as a virtual continuous multiplicity opens up the dimension of thinking and the engagement of memory, which is that of the spiritual within a secular frame.

If the simultaneity of several distinct fluxes represents an ongoing interest in Macdonald's video productions—from *Brakestand* to *Interval* and from *Healer* to *House (everythinghappensatonce)*—it is to make visible time, space, and the universe beyond everyday perception and comprehension. This interest reaches a new dimension in his most recent work to be featured in the exhibition *Two Places At Once*. Taking the form of a film installation, *You Are My Nebula* (2005)—which according to the artist is a riff on the old song *You Are My Sunshine*—features a looping image projected onto a small, rickety schoolroom screen that shows an amateur astronomer's video recording of a nebula. The budding constellation twinkles, a slowly exploding light phenomenon from 1,500 light-years ago, which is to say that it took 1,500 years for the light from the nebula to reach the camera's lens. The speed of light, traveling

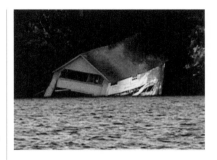

- House (everythinghappensatonce) 1999
Single-channel video projection
19:54 minutes

Klammern in Intervalle ganz anderer Dauer – die Bäume haben ihre eigene Lebensspanne und die Rotation der Erde um die Sonne verändert das Licht.

Die Autobahn zählt zu jenem Raumtypus, den der Anthropologe Pascal Augé unter dem Begriff „beliebige Räume" zusammengefasst hat: anonym, vereinheitlicht, homogen, gefangen in einem Nirgendwo zwischen Zielpunkten wie das Wirkliche bei Kubler als Nichts zwischen Ereignissen. Darüber hinaus verkörpert die Autobahn den einförmigen, reizlosen Raum, den Smithson als Topos zahlreicher Künstler seiner Generation wahrnahm und den er mit dem Erwachen eines neuen Bewusstseins verband, das die Zeit als Zerfall oder biologische Evolution verwirft und die Unsterblichkeit als Manifestation der Leere sieht.[7]

Durch die Erweiterung der psychologischen Temporalität (die den Ablauf des Alltags regelt) zu einer breiteren Erfahrung der Dauer lockert Macdonald das Regiment der Kalender und Uhren und macht unseren Zeitsinn empfänglich für die Gegenwart des Ewigen, in dem unser Leben nur ein vergänglicher Strom unter vielen ist. In *House (everythinghappensatonce)* (1999) veranschaulicht die Kamera den entropischen Prozess in Form eines alten, heruntergekommenen Bootshauses, das langsam aber sicher ins Wasser sinkt. Seine Schräglage ist so prekär geworden, dass man jeden Moment das Gefühl hat, es könnte der letzte sein. Dieser allmähliche Vorgang, der dem Betrachter endlos erscheint, wird plötzlich von einem vorbeirasenden Rennboot unterbrochen. Für die Bootspassagiere ist das Haus, wenn sie es überhaupt bemerken, nur ein kurzer Wischer im Vorüberfahren. Ein einziger Augenblick enthält also eine Dreiheit simultaner Ströme, um eine Wendung von Gilles Deleuze zu verwenden: Die Bewegung des Hauses ist so langsam, dass man sie nicht wahrnehmen kann, die des Boots so schnell, dass es ebenso unklar bleibt wie die Frage, ob die Passagiere das Haus sehen. Aber nicht nur die Attribute schnell

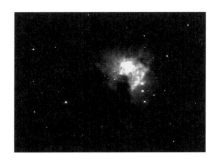

- You Are My Nebula 2005
 16mm film projection loop
 2 minutes

at 300,000 km per second, delivers an immeasurable history and brings an immense past by way of light into the very present; more strangely yet, the recording captures a history in retrospect, which is to say that a film can record a time before its own existence. Looking into such a distant past is striking if not, conceptually speaking, earthshattering, just as much as the idea that the time it will take for "today's" nebula to be seen on Earth will be a moment in which our time and even its imaginable future itself have disappeared into an unimaginably distant past. At this temporal spread, in the eternity in which our own existence is reduced to no perceptible duration, it seems that any available experience of slowness is still too fast. In that dimension of time we cannot halt the sense of our own disappearance.

You Are My Nebula, as the artist suggests, invites nostalgia, though one imagines not only for an old song. It does so in its presentation, as Macdonald translated the original video footage of the nebula (digitally recorded with a telescope in an observatory) into the older technology of film, presented through a projector in a darkened space on a domestic-use, old-fashioned film screen. Such hybridization is also an element in *Untitled with Snow* (2005)—a work in which we hear a strangely warbling and distorted ringing of church-tower bells, their harkening of the rhythm of the day and telling of time having been replaced by a pre-recorded tape that has disintegrated over time. In *You Are My Nebula*, however, we encounter two media that invite a relation to the measuring of time within media evolving from light. Film could capture a present but never offer it within the present in which it was produced. It can only be a record of a past (actual or virtual) moment. Video, on the other hand, belongs to the "transmission revolution," a tele-technology of real time that, as Virilio argued, kills "present" time by isolating it from its here and now in favor of a commutative elsewhere that no longer has anything to do with

und langsam sind in dieser Einstellung als zwei unterschiedliche, eigenständige Ströme festgehalten. „Wir nennen zwei äußere Ströme gleichzeitig, die dieselbe Dauer belegen, weil sie einander in der Dauer, in einer dritten Dauer, in der unserigen, umfassen ... [Diese] strömende Gleichzeitigkeit läßt uns die innere, die wirkliche Dauer wiedergewinnen."[8] Die Erfahrung der Dauer als virtuelle, kontinuierliche Multiplizität erschließt die Dimension des Denkens und der Erinnerung, die Dimension des Geistigen innerhalb eines profanen Rahmens.

Macdonalds Videoproduktionen verfolgen die Absicht, anhand der Gleichzeitigkeit mehrerer autonomer Ströme – von *Brakestand* über *Interval* bis zu *Healer* und *House (everythinghappensatonce)* – Zeit, Raum und Kosmos jenseits der alltäglichen Wahrnehmung und Erkenntnis zugänglich zu machen. Dieser Ansatz erfährt im neuesten Werk, das in *Two Places At Once* präsentiert wird, eine noch deutlichere Ausprägung. *You Are My Nebula* (2005) ist als Filminstallation ausgelegt. Der Titel, verrät der Künstler, ist vom Song *You Are My Sunshine* inspiriert. Auf eine kleine, wackelige Schulleinwand wird die Endlosschleife eines Videos projiziert, das ein Amateurastronom aufgenommen hat. Es zeigt einen flimmernden, langsam explodierenden Sternennebel in 1500 Lichtjahren Entfernung, das Bild des Nebels hat also 1500 Jahre benötigt, um die Linse der Kamera zu erreichen. Das Licht, das sich mit 300.000 km pro Sekunde fortbewegt, trägt eine immense Geschichte und Vergangenheit in die Gegenwart. Noch merkwürdiger an dieser Aufnahme ist, dass sie ein historisches Ereignis im Rückblick aufzeichnet; ein Film ist also im Stande, eine Zeit zu dokumentieren, die weiter zurückliegt als seine eigene Entstehung. Der Blick in eine derart ferne Vergangenheit ist faszinierend, wenn nicht gar, konzeptuell gesehen, welterschütternd, im selben Maß wie der Gedanke, dass dann, wenn das Bild des „heutigen" Nebels die Erde erreicht, unsere Ära mitsamt aller uns noch vorstellbaren Zukunft in eine unglaublich ferne Vergangenheit versunken sein wird. Im Vergleich zu dieser in Äonen gemessenen Zeit, zu dieser Ewigkeit, die unsere Existenz auf eine kaum noch wahrnehmbare Kürze reduziert, wirkt jede verfügbare Erfahrung der Langsamkeit noch immer übermäßig schnell. Man hat angesichts dieser Zeitdimension unweigerlich das Gefühl zu verschwinden.

Wie der Künstler selbst einräumt, bringt *You Are My Nebula* eine Nostalgie ins Spiel, die sicherlich nicht nur dem Evergreen gilt. Sie bestimmt sogar die Präsentation des Werks, denn Macdonald hat das Originalvideo des Sternennebels (eine Digitalaufnahme durch das Teleskop eines Observatoriums) in das ältere

- Untitled with Snow 2005
 Single-channel video projection
 7 minutes

a concrete presence in the world, but is the else-where of a discrete telepresence. Time, as Virilio wrote, can no longer be considered without the help of the illumination of an absolute speed, the luminocentrism of the speed of light. "To the pass-ing time of the longest durations, we now add accordingly a time that is exposed instantaneously: the time of the shortest durations in the realms of electromagnetism and of gravity."[9]

If we follow McLuhan, we might see in Mac-donald's hybrid meeting of two media (a newer il-luminated by an older one) a moment of revelation: "For the parallel between two media holds us on the frontiers between forms that snap us out of the Narcissus-narcosis. The moment of the meeting of media is a moment of freedom and release from the ordinary trance and numbness imposed by [each of] them on our senses."[10] It is also possible to argue, along the path of Macdonald's recent work, that the interest in slowness is not a nostalgia for a past plea-sure so much as it is for the very ability to experience duration in the burgeoning era of instant synchro-nicity, a perpetual overexposed presentness trans-mitted by digital technology—at the speed of light.

Notes

1. The summer 2005 issue of *Frieze* magazine was de-voted to it, as was the 2005 Lyon Biennale exhibition *Experience Duration*, and *Slow Art—The Current Art Scene* at the Museum Kunst Palast, Düsseldorf, Germany, in the fall of 2005. See also, for instance, the Canadian bestseller Carl Honoré's *In Praise of Slow: How a Worldwide Movement Is Challenging the Cult of Speed* (Toronto: A. A. Knopf Canada, 2004).

2. The first example is an installation by Carsten Höller and Rosemarie Trockel at Documenta X, Kassel, Germany, in 1997; the second a film by Tacita Dean; and the third a work by Jeff Wall titled *A Sudden Gust of Wind (after Hokusai)* (1993).

3. Cited in Robert Smithson, *Quasi-Infinities and the*

Medium des Films übertragen, der in einem ver-dunkelten Raum mittels Projektor auf eine altmodische Hobbyleinwand geworfen wird. Derselben Hybridisie-rung begegnen wir in *Untitled with Snow* (2005): Das Läuten von Kirchenglocken, das den Tag rhythmisch segmentiert und die Stunden verkündet, klingt ver-zerrt und seltsam zwitschernd, da es von einem Band abgespielt wird, das nicht im besten Zustand erhalten ist. *You Are My Nebula* ersetzt dieses akustische Register durch die relative Zeitmessung zweier Medien, die Lichtsignale aufnehmen. Der Film kann eine Gegen-wart einfangen, diese aber nie im selben Moment wiedergeben, er dokumentiert stets eine vergangene (tatsächliche oder virtuelle) Situation. Das Video zählt dagegen zu den Errungenschaften der „Übertragungs-revolution", es ist eine Teletechnologie mit Echtzeit-Kapazität. Nach Ansicht von Paul Virilio tötet das Video die „gegenwärtige" Zeit, indem es diese aus dem Hier und Jetzt löst und einem kommunikativen Anders-wo übergibt, das keine konkrete Präsenz in der Welt hat, sondern einer diskreten Telepräsenz angehört. Die Zeit, schreibt Virilio, ist nur mehr vorstellbar, wenn sie im Strahl einer absoluten Geschwindigkeit erscheint, im Luminozentrismus der Lichtgeschwindig-keit. „Zur verstreichenden Zeit der längsten Perioden gesellt sich nun eine Zeit, die blitzartig *belichtet* wird: die Zeit der kürzesten Perioden im Bereich des Elek-tromagnetismus und der Schwerkraft."[9]

Im Sinne Marshall McLuhans ließe sich Macdonalds Verschmelzung zweier Medien (ein neueres Medium erhellt durch ein älteres) als Moment der Offenbarung deuten: „Denn die Parallele zwischen zwei Medien läßt uns an der Grenze zwischen Formen verweilen, die uns plötzlich aus der narzisstischen Narkose her-ausreißen. Der Augenblick der Verbindung von Medien ist ein Augenblick des Freiseins und der Erlösung vom üblichen Trancezustand und der Betäubung, die sie sonst unseren Sinnen aufzwingen."[10] Darüber hinaus könnte man in Bezug auf Macdonalds jüngste Schaf-fensphase argumentieren, dass das Interesse an der Langsamkeit nicht aus einer Nostalgie für vergangene Genüsse resultiert, sondern vielmehr aus einer Nos-talgie für das grundlegende Erleben der Dauer in einer Ära, die immer stärker von einer augenblicklichen Gleichzeitigkeit geprägt ist, einer permanenten, über-flutenden Gegenwärtigkeit, übertragen von Digital-technologien – mit der Geschwindigkeit des Lichts.

Aus dem Englischen übersetzt von Bernhard Geyer.

Anmerkungen

1. Die Sommerausgabe 2005 der Zeitschrift *Frieze* ist diesem Thema gewidmet, die Biennale von Lyon

Waning of Space, in: *The Writings of Robert Smithson*, ed. Nancy Holt (New York: New York University Press, 1979), 32.

4. Paul Virilio, *Open Sky*, trans. Julie Rose (London: Verso, 1997), 25. Jeff Wall's observation on conceptualist artists' anaesthetic and apparently indifferent position vis-à-vis their subject may be equally applicable to the maker of video work, who shares a certain quality with that of a driver. As Wall observed of Ed Ruscha's *Twenty-six Gasoline Stations* (1962), "only an idiot would take pictures of nothing but the filling stations, and the existence of a book of just those pictures is a kind of proof of the existence of such a person." That is, the pictures render the maker of the picture "the asocial cipher who cannot connect with the others around him…an abstraction, a phantom conjured up by the construction" of the work. Such a phantom producer is "unable to avoid bringing into visibility the 'marks of indifference'" in which Wall reads, after Adorno, the way "with which modernity expresses itself in or as a 'free society.'" Wall, "'Marks of Indifference': Aspects of Photography in, or as, Conceptual Art" (1995), in Douglas Fogle, *The Last Picture Show: Artists Using Photography 1960–1982* (Minneapolis: Walker Art Center, 2003), 43–44.

5. Smithson, *Letter to the Editor*, in: *Artforum*, October 1967, reprinted in: *The Writings of Robert Smithson*, 38.
6. David E. James, *Artists as Filmmakers in Los Angeles*, in: *October*, no. 112 (spring 2005): 119.
7. Smithson, *Entropy and the New Monuments*, in: *The Writings of Robert Smithson*, 10–12.
8. Gilles Deleuze, *Bergsonism*, trans. Hugh Tomlinson and Barbara Habberiam (New York: Zone Books, 1988), 80.
9. Virilio, *Open Sky*, 3, 11.
10. Marshall McLuhan, *Understanding Media* (New York: New American Library, 1964), 63.

2005 trägt den Titel *Die Erfahrung der Dauer* und im Düsseldorfer Museum Kunst Palast findet im Herbst 2005 die Ausstellung *Slow Art – Stilleben, Porträts, Landschaften* statt. Siehe auch den Bestseller des Kanadiers Jean-Carl Honoré, *Slow Life: Neue Kreativität und Lebensqualität durch die Verwirklichung von Eigenzeit* (München 2004).

2. Das erste Beispiel ist eine Installation von Carsten Höller und Rosemarie Trockel für die Documenta X, Kassel, 1997; das zweite ein Film von Tacita Dean; und das dritte ein Werk von Jeff Wall mit dem Titel *A Sudden Gust of Wind (after Hokusai)* (1993).

3. Zitiert nach Robert Smithson, *Quasi-Infinities and the Waning of Space*, in: *The Writings of Robert Smithson*, hrsg. von Nancy Holt (New York 1979), S. 32.

4. Paul Virilio, *Open Sky*, übers. von Julie Rose, (London 1997), S. 25. Die Beobachtung Jeff Walls, dass Konzeptkünstler ihrem Gegenstand empfindungslos und offenbar indifferent gegenüberstehen, könnte auch auf Videokünstler ausgedehnt werden, die eine bestimmte Eigenschaft mit Autofahrern gemeinsam haben. Wall bemerkte zu Ed Ruschas *Twenty-six Gasoline Stations* (1962), nur „ein Idiot würde Aufnahmen machen, die einzig und allein Tankstellen zeigen, und die Tatsache, dass ein Buch mit ebensolchen Bildern existiert, ist ein Beweis, dass eine solche Person existiert". Denn „die Bilder machen ihren Erzeuger, die asoziale Null, die keinen Kontakt findet zur Welt rundherum, zu einer Abstraktion, zu einem Phantom, heraufbeschworen von der Konstruktion" des Werks. Ein solcher Phantom-Erzeuger kann „nicht vermeiden, dass er die ‚Zeichen der Indifferenz' sichtbar werden lässt, die Jeff Wall in Anlehnung an Adorno als jenes Mittel versteht, mit dem sich die Moderne in einer ‚freien Gesellschaft' oder als eine ‚freie Gesellschaft' ausdrückt". Wall, *Marks of Indifference: Aspects of Photography in, or as, Conceptual Art*, in: Douglas Fogle, *The Last Picture Show: Artists Using Photography 1960–1982* (Minneapolis 2003), S. 44.

5. Smithson, Letter to the Editor, in: *Artforum*, October 1967, Neudruck in: *The Writings of Robert Smithson*, S. 38.
6. David E. James, *Artists as Filmmakers in Los Angeles*, in: *October* (Herbst 2005): S. 119.
7. Smithson, *Entropy and the New Monuments*, in: *The Writings of Robert Smithson*, S. 10–12.
8. Gilles Deleuze, *Henri Bergson zur Einführung* (Hamburg, 2001), S. 105.
9. Virilio, *Open Sky*, S. 3, 11.
10. Marshall McLuhan, *Die magischen Kanäle. Understanding Media* (Düsseldorf 1992), S. 73.

- Untitled 2003
 C-print
 Three parts: 76,2 x 50,8 cm each

28

30

- Accident 2001
 Ink on paper
 38 x 27 cm

- Rearview Mirror 2003
Ink on paper
70 x 54 cm

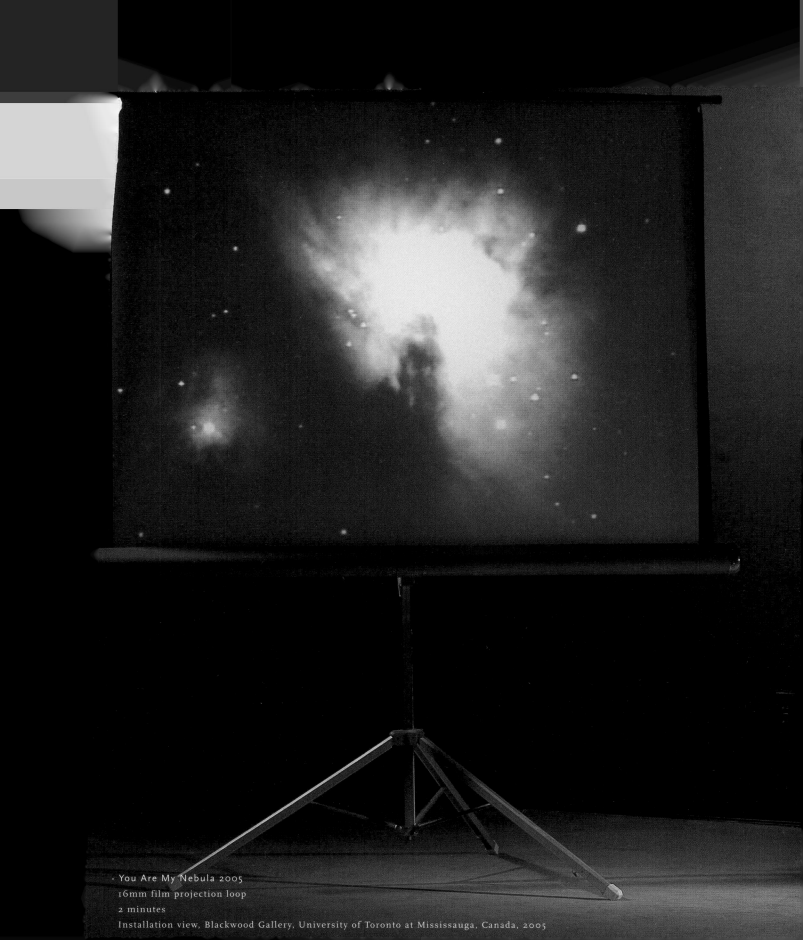

- You Are My Nebula 2005
16mm film projection loop
2 minutes
Installation view, Blackwood Gallery, University of Toronto at Mississauga, Canada, 2005

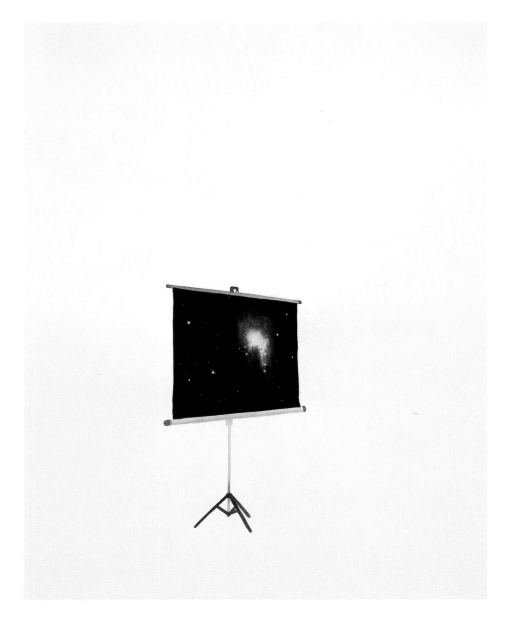

- Nebula Projection Screen 2005
Gouache on paper
Three parts: 50 x 65 cm each

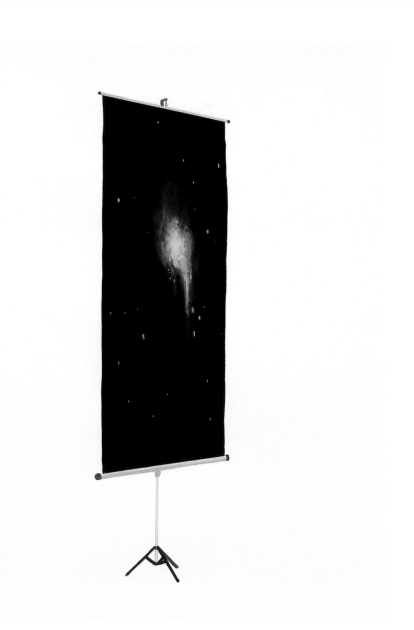

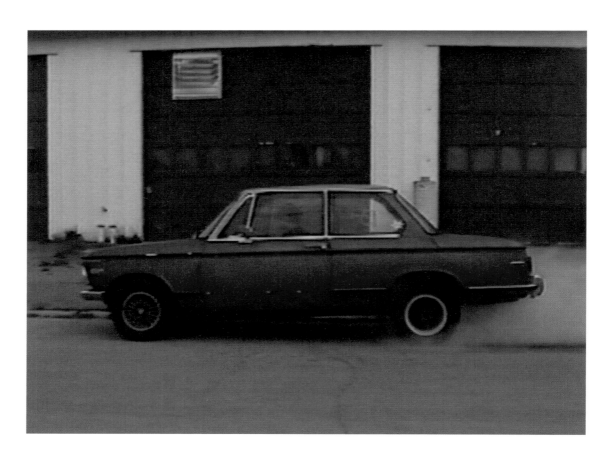

- Brakestand 1998
 Single-channel video projection
 15 minutes

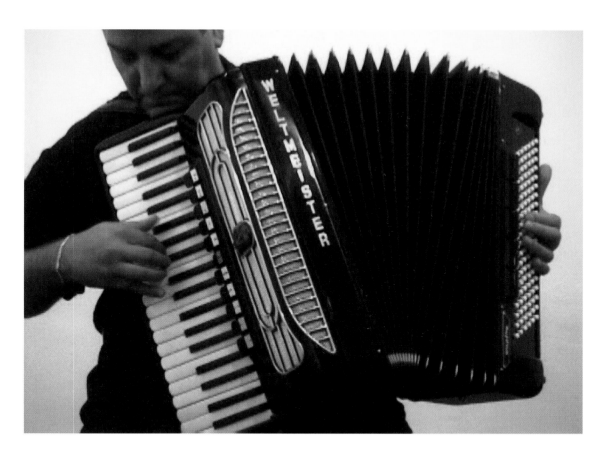

- The Weltmeister 2004
 Single-channel video projection
 2 minutes

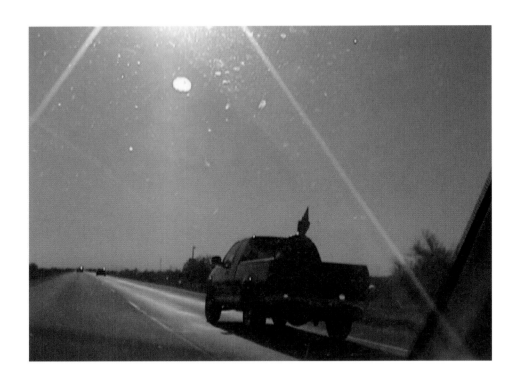

38

- SCLPTR 2003
 Single-channel video projection
 2 minutes

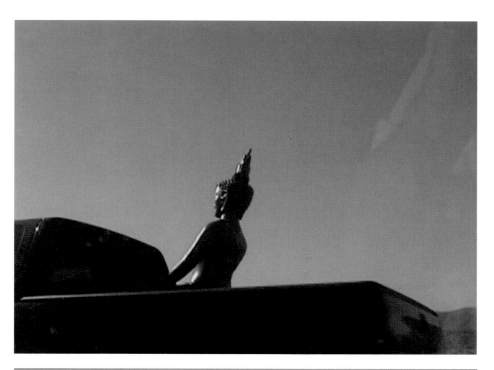

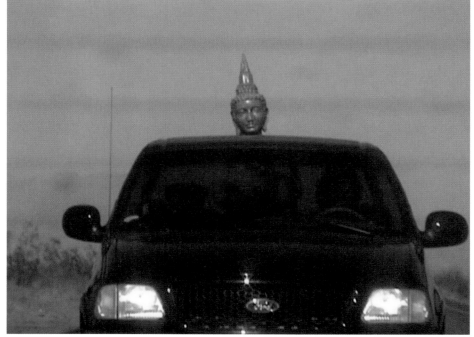

- Untitled with Snow 2005
 Single-channel video projection
 7 minutes

42

- You Are My Sunshine 2005
 16mm film projection loop
 2:20 minutes

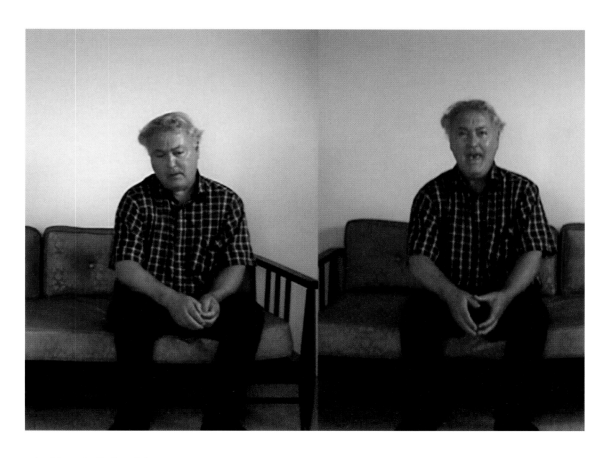

43

- doubleportraitofayodeler 2003
 Single-channel video projection
 1:25 minutes

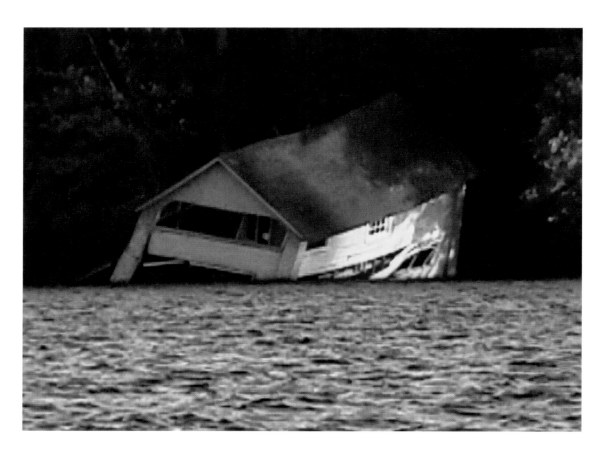

44

- House (everythinghappensatonce) 1999
Single-channel video projection
19:54 minutes

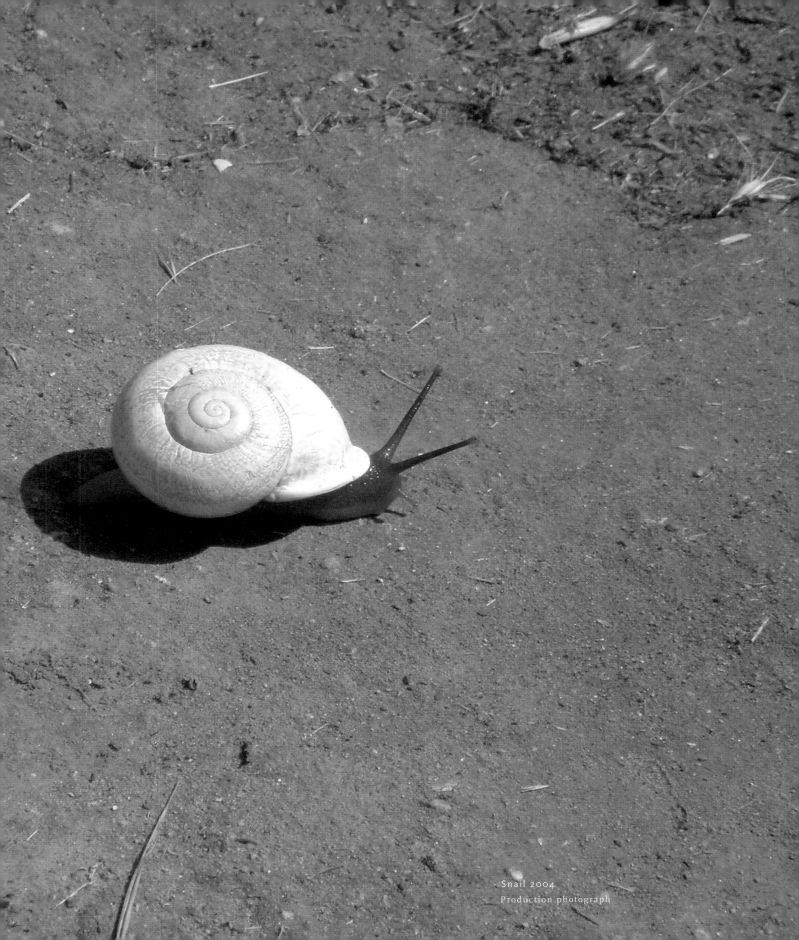

Snail 2004
Production photograph

46

- Two Planes 1999
 Single-channel video projection
 2 minutes

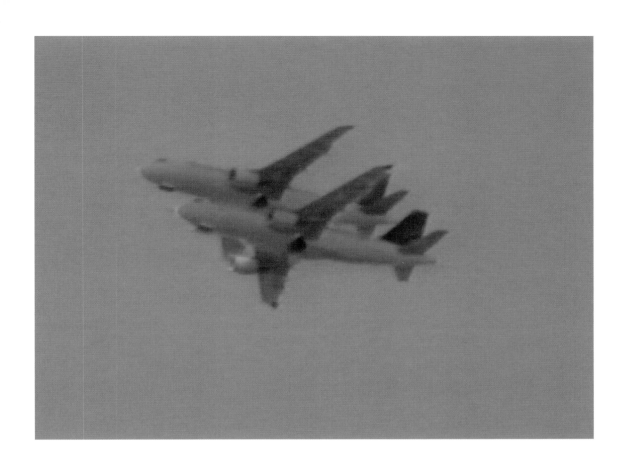

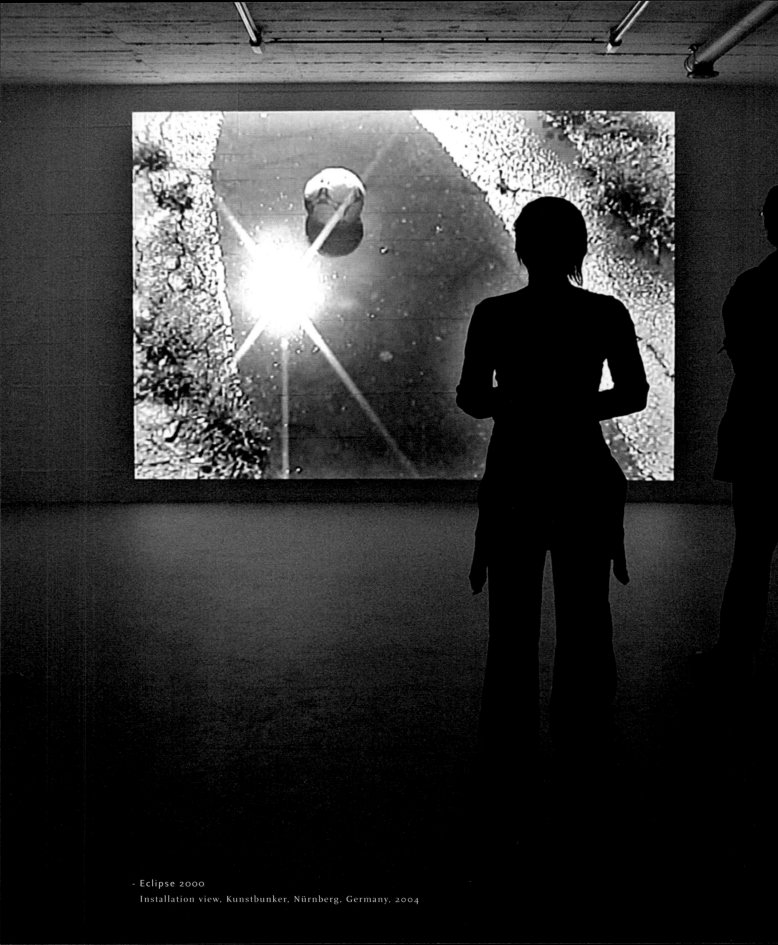

- Eclipse 2000
Installation view, Kunstbunker, Nürnberg, Germany, 2004

shadows of the continuous universe: euan macdonald's art of synchronic perception

Schatten des kontinuierlichen Universums: Euan Macdonalds Kunst der synchronistischen Wahrnehmung

Midori Matsui

Euan Macdonald's video works conceal mystery within deceptively simple structures. Focusing on objects and scenes from the everyday, he records actions during which no spectacular events take place. Nevertheless, he enables the audience to perceive the world in a new way by indicating connections between seemingly distinct things and presenting the duration of time as an internally integrated and tangible experience.

This is accomplished through two distinct strategies. One is Macdonald's repetition of the same action occurring at close intervals, without giving any apparent cause for their near simultaneity. The most obvious example of this is *Three Trucks* (2000), in which a white ice-cream truck playing a loud and warbling rendition of *It's a Small World* pulls up to an intersection and stops; it is joined moments later by a second truck blaring the same song. A third truck soon pulls up, its tune impossible to discern from the chorus of maddeningly clashing tunes. The arrival of the second truck establishes a relation between separate phenomena and indicates the possibility of an infinite repetition of this action, which the third truck confirms. The video ends shortly after the arrival of the third truck, thus framing the sequence as meaningful, hinting at an intervention of some hidden order beyond human

Euan Macdonalds Videowerk verbirgt Geheimnisse hinter täuschend einfachen Strukturen. Er dokumentiert Vorgänge, in denen nichts Außergewöhnliches geschieht und alltägliche Objekte und Szenen die Hauptrolle übernehmen. Dennoch gibt er dem Betrachter die Möglichkeit, die Welt auf neue Art zu erleben, indem er Verbindungen zwischen Dingen herstellt, die oberflächlich nichts miteinander gemein haben, und indem er das Verstreichen der Zeit als innerlich kongruente und konkrete Erfahrung präsentiert.

Diese künstlerische Absicht wird mithilfe zweier unterschiedlicher Strategien realisiert. Die erste ist die Wiederholung derselben Handlung innerhalb einer kurzen Zeitspanne, ohne dass ein ersichtlicher Grund für die annähernde Gleichzeitigkeit besteht. Als Musterbeispiel hierfür kann das Video *Three Trucks* (2000) dienen, in dem ein weißer Eiswagen an einer Kreuzung hält, aus dessen Lautsprechern eine laute, klingelnde Fassung von *It's a Small World* dröhnt. Kurz darauf gesellt sich ein anderer Eiswagen zu ihm, der dieselbe Musik verbreitet, und dann ein dritter, so dass ein Chor ohrenbetäubender, durcheinander schallender Melodien entsteht. Die Ankunft des zweiten Wagens stellt eine Beziehung zwischen zusammenhangslosen Phänomenen her und deutet die Möglichkeit einer endlosen Wiederholung dieses Geschehnisses an, die vom dritten

- Three Trucks 2000
Single-channel video projection
2 minutes

intent. Although the content of the hermetic order is left unexplored, a sense of the strange evoked by coincidence retains the possibility of action and therefore the perception that escapes causal determination.

The same theme is given a symbolic resonance by *GAD* (2004). Here, three guitars of different sizes are propped against a wall. One by one they slide down the wall, hitting the floor with a crash that reverberates. Each guitar's fall is presented not as the consequence of the former guitar falling but as a new instance each time. The distinctive sounds made by each guitar echo one another, creating an accidental harmony. The fact that the coincidental repetition of simular actions in these two pieces is staged, aiming at a comedic timing, does not diminish the impression of an alternative experience of time brought to our attention by the simple breach and rearrangement of its continuum.

Such repetitions can be regarded as minor cases of synchronicity, the Jungian concept of two or more phenomena with similar content occurring at once or within a close interval without any causal determination: "the simultaneous occurrence of meaningful equivalences in heterogeneous, causally unrelated processes."[1] Carl Jung ascribed the idea of synchronicity to that of correspondence—the theory of a God-created universe with each part reflecting his design that therefore found equivalence and sympathy with apparently distinct phenomena—believed in during the early modern age and elaborated by Gottfried Leibniz's idea of monadology.[2] For Leibniz, the monad was the principle constituent of the universe, a simple substance whose prime characteristic is to change. In spite of its simplicity, its substance contains a "variety of relations of correspondence ... with things outside" and produces "the plurality of modifications" through the movement and interactions of monads: "everywhere there are simple substances actually separated from each

Wagen bestätigt wird. Das Video endet kurz nach dem Erscheinen des dritten Wagens und erhält dadurch einen Bezugsrahmen, der dem Ganzen Sinn gibt und auf den Einfluss einer verborgenen Macht jenseits des menschlichen Wollens verweist. Obwohl das Wesen dieser hermetischen Macht nicht näher untersucht wird, bewahrt der vom Zufall hervorgerufene Eindruck, dass es nicht mit rechten Dingen zugeht, die Möglichkeit des Handelns und damit einer Wahrnehmung, die sich dem Kausalnexus entzieht.

Dasselbe Motiv erhält in *GAD* (2004) symbolische Resonanz. Drei verschieden große Gitarren lehnen an einer Wand. Eine nach der anderen verliert den Halt und fällt polternd auf den Boden. Jeder Sturz wird nicht als Folge des vorhergehenden dargestellt, sondern als stets neues Ereignis. Der unverwechselbare Klangcharakter jedes Instruments hallt in den anderen wider und erzeugt so eine unbeabsichtigte Harmonie. Der Umstand, dass die zufällige Wiederholung desselben Vorgangs in beiden Werken inszeniert ist und in humorvoll wirkenden Intervallen erfolgt, schwächt nicht den Eindruck eines neuen Erlebens der Zeit, das uns durch die einfache Durchbrechung und Neuordnung ihres Kontinuums erschlossen wird.

Wiederholungen dieser Art können als sekundäre Fälle der Synchronizität gewertet werden, die laut C. G. Jung dann zu beobachten ist, wenn zwei oder mehrere Phänomene ähnlichen Inhalts ohne ursächlichen Zusammenhang zur gleichen oder nahezu gleichen Zeit auftreten: „das simultane Vorhandensein von sinngemäßer Gleichartigkeit in heterogenen, kausal nicht verbundenen Vorgängen".[1] Jung verband die Idee der Synchronizität mit jener der Korrespondenz – der Anschauung, dass jeder Teil der von Gott erschaffenen Welt den Schöpfungsplan in sich trägt und dass demzufolge Phänomene, zwischen denen anscheinend kein Zusammenhang besteht, durch Entsprechung und Sympathie miteinander verbunden sind –, die während des 17. und 18. Jahrhunderts weit verbreitet war und

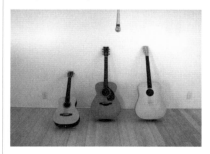

- GAD 2004
Single-channel video projection
1 minute

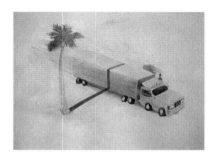

- Untitled (Interval) 2003
Ink on paper
45 x 35 cm

other by their own actions, which continually change their relations."[3] Leibniz called this mutual affecting of monads the "Laws of Continuity." He maintained that "the sequence of things dispersed through the universe of created things," and "the immense variety of things in nature and ad infinitum division of bodies" constitute "the interlinkage ... of all created things to each other, in which each part refers to the rest of the universe."[4] This idea gave a foundation for Jung's idea of synchronicity.

The second strategy of Macdonald is the recording of one continual action or scene with a stationary camera without willful artistic interventions. A typical example can be found in his early piece *Interval* (1997). In it, the swaying shadows of two palm trees stretch over a multiple-lane road, suggesting a different order of experience from the banal continuum of time in the everyday.

The more powerful example of a stationary camera capturing the experience of time perceived as qualitatively different than the mere passage of action is presented by *House (everythinghappensatonce)* (1999), an approximately twenty-minute record of a dilapidated house precariously balanced on the bank of a river. Though the house appears to be sinking into the river, no change in its position is discernible for the duration of the video. One perceives the passage of time through the fluttering leaves of the trees behind the house and the shifting of light on its walls and roof. Shapes are distinct at first but soften with the waning light of the setting sun.

However, the sense of time's passage is more directly conveyed by sound. The constant flow of the river is articulated and given variation by the rippling and lapping sounds of water that constantly change in pace, frequency, and volume. The perpetual change of the sounds awakens the perception of the audience to the immediacy of the present occurrence while accumulating the gravity of time as

in die Monadenlehre von Gottfried Wilhelm Leibniz Eingang fand.[2] Die Monade galt Leibniz als Baustein der Natur, als einfache Substanz, die sich vor allem durch ihre Veränderlichkeit auszeichnet.[3] Ungeachtet ihrer Einfachheit enthält die Substanz eine „Verschiedenheit der Beziehungen zu den Dingen, die außer ihr sind", und erzeugt durch ihre Bewegung und ihr Zusammenwirken mit anderen Monaden „die Vielfältigkeit der Modifikationen": „Es gibt überall einfache Substanzen, die tatsächlich durch eigene Handlungen voneinander geschieden sind und die dauernd ihre Beziehungen zueinander ändern."[4] Die Wechselwirkung der Monaden bezeichnete Leibniz als „Gesetz der Kontinuität".[5] Er sah „in der Folge der durch das Universum der Geschöpfe verbreiteten Dinge" sowie in der „unermeßlichen Vielfalt der Naturdinge" und „der Teilung der Körper bis ins Unendliche" das Band, das diese „Verknüpfung oder diese Anpassung aller erschaffenen Dinge an jedes einzelne von ihnen und jedes einzelnen an alle anderen bewirkt", so dass jede einfache Substanz „ein dauernder lebendiger Spiegel des Universums ist".[6] Leibniz bereitete damit den Boden für Jungs Synchronizitätsprinzip.

Die zweite Strategie Macdonalds ist die Aufzeichnung einer kontinuierlichen Handlung oder Szene mit feststehender Kamera, ohne sie durch gezielte künstlerische Eingriffe zu verändern. Ein typisches Beispiel gibt das Frühwerk *Interval* (1997). Zwei schwankende Palmen werfen ihre Schatten über eine mehrspurige Fahrbahn und deuten damit auf eine andere Erfahrungsebene hin als den banalen Lauf der Zeit im Alltagstrott.

Eine noch eindringlichere Verwendung der festen Kamera zur Visualisierung einer Zeiterfahrung, die qualitativ anders wahrgenommen wird als der bloße Ablauf einer Handlung, gelingt in *House (everythinghappensatonce)* (1999), einer zirka zwanzig Minuten langen Dokumentation eines baufälligen Hauses, das am Ufer eines Flusses einzustürzen droht. Trotz dieser akuten Gefahr ist während der Dauer des Videos keine

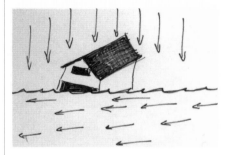

- Untitled (House) 2000
Ink on paper
33 x 25,5 cm

a palpable presence. While in *Interval*, in which the movement of cars on the street plays against the subtle fluctuation of the shadows of the palm trees that indicate internally perceived time, in *House* it is the fast movement of the river, its endless repetition of ripples and waves, that attains a simultaneously material and inner presence. The run of the river can be perceived as the true constant of the present against the deceptive appearance of the house frozen in a state of collapse.

The experience illustrated by *House* points to duration, Henri Bergson's idea of the subjective perception of time that achieves an internal consistency while constituting a lived experience. A case of a "change or a becoming that endures," duration reconciles heterogeneity and continuity.[5] In the Bergsonian theory of duration, space is not regarded as a location in which to perceive a genuine change, since spatial movement merely reveals a change in the degree of the arrangement of things. By contrast, a change in time brings about the perception of change in kind, with each moment embodying the unique power of occurrence.[6]

The action in *House* is essentially reduced to the same static level as a picture on the wall; however, the video's spatial limitations effectively emphasize the significance of sound and time. The shift of emphasis from the visible to the audible makes the audience aware of a way of perceiving the phenomenal world other than the merely visual. The sound of water creates a continuous yet distinct stimulus. The audience can then respond to the intensity of the phenomenon occurring in the work; the sound of water enables the audience to experience temporal change as a physical effect that also determines the momentum of their perception. Thus the external phenomenon is internalized, and the internal experience is given an actual referent. This process, in short, embodies duration. The sound of water, with its myriad inflections, marks the phases of perception while constituting the

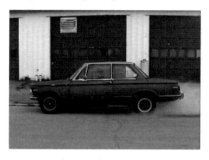

- Brakestand 1998
Single-channel video projection
15 minutes

Positionsveränderung erkennbar. Dass die Zeit vergeht, merkt man nur am Zittern des Laubs an den Bäumen hinter dem Haus und am Wandern des Lichts über Dach und Wände. Die anfangs deutliche Modellierung der Formen beginnt sich aufzulösen, als mit der sinkenden Sonne die Dämmerung hereinbricht.

Noch direkter vermittelt jedoch der Ton des Videos das Verrinnen der Zeit. Das unablässige Vorüberströmen des Flusses wird artikuliert und variiert vom Klatschen und Plätschern des Wassers, was sich in Tempo, Frequenz und Lautstärke ständig ändert. Die Gleichförmigkeit und fortdauernde Modulation des Geräuschs lenkt die Aufmerksamkeit des Publikums auf das Da-Sein des ablaufenden Ereignisses und verdichtet die Schwere der Zeit, so dass ihre Gegenwart spürbar wird. *Interval* kontrastiert die Fortbewegung der Autos auf der Straße mit dem sanften Schwingen der Schatten der Palmen, das eine innerlich wahrgenommene Zeit evoziert, während in *House* die eilige Bewegung des Flusses, sein unaufhörliches Hervorbringen neuer Wellen und Wirbel, sowohl eine materielle als auch eine innere Präsenz schafft. Die Strömung des Flusses kann als wahre Konstante der Gegenwart genommen werden, an der die trügerische Erscheinung des im Zusammensturz erstarrten Hauses gemessen wird.

Die Sichtweise, die *House* illustriert, bringt uns zur Dauer, Henri-Louis Bergsons Theorie von der subjektiven Wahrnehmung der Zeit, die eine innere Einheit erzielt und zugleich eine gelebte Erfahrung darstellt. Die Dauer – ein „Werden, aber ein Werden, das dauert" – bringt Heterogenität und Kontinuität zusammen.[7] Bergsons Begriff der Dauer versteht den Raum nicht als Ort, an dem echte Wesensunterschiede feststellbar sind, da die räumliche Bewegung nur graduelle Unterschiede in der Ordnung der Dinge aufzeigt. Im Gegensatz dazu führt eine Veränderung der Zeit zur Wahrnehmung eines Wesensunterschieds, wobei der Eintritt jedes Moments eine ihm eigene Wirkung entwickelt.[8]

Die Handlung von *House* bleibt beinahe auf das statische Niveau eines Bilds an der Wand reduziert. Aber gerade die räumliche Begrenztheit des Videos steigert effektiv die Bedeutung von Ton und Zeit. Der Betonungswechsel vom Sichtbaren auf das Hörbare öffnet das Bewusstsein für ein Erfassen der Erscheinungswelt, das über bloß visuelle Reize hinausgeht. Das Rauschen des Flusses regt auf gleichförmige und doch eigentümliche Art an. Das Publikum ist damit bereit, auf die Intensität der vom Werk dargebotenen Phänomene einzugehen; stimuliert vom Geräusch des Wassers, empfindet es die Veränderung der Zeit als physischen

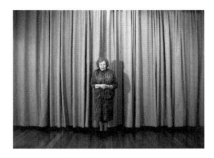

- Healer 2002
Single-channel video projection
5 minutes

whole experience of hearing the river; it recapitulates and encourages an experience of duration that "actualizes itself by creating lines of differentiation that correspond to its differences in kind."[7]

A similar strategy is seen in *Brakestand* (1998), which shows a car whose engine revs at high speed while its brake is on. This causes the back tires to spin frantically, burning rubber while the front tires stay still. *Healer* (2002) conveys the physical effect of duration by showing a woman standing on stage facing the camera for five minutes, as if to exercise her psychic influence on us, the viewers. The former represents the paradox of an object capable of motion as incapable of moving. The car's inability to move is highlighted by a horrible screeching sound and clouds of smoke, made by the tires vainly spinning against the ground, which intensifies over time. For the viewer, the frustration with the lack of spatial change—despite the expended energy—is replaced by an acute perception of time, making one aware of the "wasted" action's gravity and materiality almost as an assault on the senses. *Healer* makes performative content out of the woman's own performance: the psychic's silent stare replaces her personality, becoming a singular act that conveys the weight of time and her will as a physical force. The performance produces "affect," defined by Gilles Deleuze as a variation of power produced by the influence of one's body acting on another.[8]

These two strategies indicate a specific worldview that values change in time as a fundamental factor in the relatedness of all things. Leibniz's monadology explains this worldview well. For Leibniz, the soul is also a monad, in whose structure "a multitude of thoughts" is formed by "a particular change according to what it involves ... by virtue of its essential relationship to all other things"; for that reason, the soul also reflects the ways of the universe.[9] Perception is "the inner state of the monad representing external things" and is to be distinguished

Effekt, der auch die Dynamik der Wahrnehmung bestimmt. Die äußerliche Erscheinung wird internalisiert, die innere Erfahrung erhält einen konkreten Referenten. Kurz gesagt, dieser Prozess verkörpert die Dauer. Das Wassergeplätscher mit seinen unzähligen Abwandlungen markiert die Phasen der Kognition und bedingt gleichzeitig die gesamte akustische Wahrnehmung des Flusses; es wiederholt und verstärkt eine Erfahrung der Dauer, die sich aktualisiert, „indem sie Differenzierungslinien ausbildet, die entlang von Wesensunterschieden verlaufen".[9]

Eine ähnliche Strategie ist in *Brakestand* (1998) am Werk: Der Motor eines Autos läuft mit hoher Drehzahl, während die Bremse die Räder blockiert. Die Hinterräder drehen sich durch, „dass der Gummi raucht", während die Vorderräder stillstehen. In *Healer* (2002) tritt der physische Effekt der Dauer in Gestalt einer Frau auf, die auf der Bühne stehend fünf Minuten lang in die Kamera blickt, als wollte sie ihre übersinnlichen Kräfte auf die Zuschauer wirken lassen. Das erste Werkbeispiel konfrontiert uns mit dem Paradox eines beweglichen Objekts, das unfähig ist, sich zu bewegen. Den Stillstand des Autos unterstreichen dramatisch das Aufheulen des Motors und der Rauch, der von den immer ungestümer auf dem Belag rotierenden Reifen aufsteigt. Der Unmut des Betrachters angesichts der – trotz des Energieaufwands – unverändert beharrenden Raumsituation wird ersetzt durch ein akutes Zeitbewusstsein. Der greifbare, materielle Ernst der „verschleuderten" Anstrengung wirkt fast wie ein Attacke auf die Sinne. *Healer* extrahiert einen performativen Inhalt aus dem Auftritt der Frau: An die Stelle des Charakters der Heilerin tritt ein unverwandtes Starren, ein resoluter Akt, der ihre Willensstärke und das Gewicht der Zeit als physische Kraft zur Wirkung bringt. Die Performance erzeugt „Affekte", die Gilles Deleuze als Variationen von Vermögen definiert, erzeugt durch die Wirkung eines Körpers auf einen anderen.[10]

Beide Strategien kennzeichnen eine spezifische Weltsicht, die in der Veränderung der Zeit einen elementaren Faktor im Zusammenhang der Dinge sieht. Leibniz zeichnet in seiner Monadologie ein klares Bild dieser Anschauung. Die Seele ist für ihn gleichfalls eine Monade, in deren Struktur „eine Menge von gegenwärtigen Gedanken ... nach einer Sonderveränderung strebt ... vermöge der wesentlichen Beziehung derselben zu allen anderen Dingen der Welt". Aus diesem Grund ist die Seele auch ein Spiegel des Universums.[11] Leibniz unterscheidet zwischen Perzeption, die „der innere Zustand der die äußeren Dinge darstellenden Monade ist", und der Apperzeption, die „die reflexive Erkenntnis dieses inneren Zustands ausmacht".[12]

53

from apperception, which is the "reflective knowledge of this inner state itself."[10]

In Macdonald's video work, accidental occurrences can be seen as signs of the connectedness among individual phenomena—a correspondence between internal acts of the mind and external events. Again, *House* combines the experience of synchronicity with that of duration. The simple continuity of the picture is momentarily disrupted near the beginning of the twenty-minute video by the traversing of a boat across the screen. When another boat finally crosses the screen near the end of the video, it strikes the audience as a gift, an act that gives a sense of order to the continuum of the perpetual present. Macdonald's creation of the video's time frame produces this illusion of synchronicity. In that sense, his video indicates the internal continuity of the natural world and human perception by embodying the experiences of synchronicity and duration.

The simultaneous act of opening one's mind to the immediacy of occurrences and searching for a sign of correspondence is compactly expressed in *Eclipse* (2000). Slowly rotating and floating in a puddle, a ball plays with the reflection of the sun, hiding and revealing the glittering circle with its own round shadow. The formal repetition of circles eclipsing modestly points out the connectedness of all things.

Leibniz's vision of interconnectedness presupposed "the plenitude of the world" in which "each body acts on every other" and is "affected by the reaction," presenting a picture of totality while also suggesting a divergence of many actions unconstrained by consciousness or causality: "For all is a plenum, which renders all matter interconnected, and as in a plenum any motion has some effect on distant bodies in proportion to that distance—so that each body is affected not only by those that touch it, in some way feeling the effects of all that happens to them, but also through their mediation feeling affected by those in contact with the former … it follows that this inter-communication extends to any distance, however great."[11]

Although Macdonald's art does not consciously embrace the Leibnizian "plenitude," it responds to the implications of the freedom of connection among things made through their interactions. The repetition of simple events in his works cannot be reduced to the generalized concept of the same, as they assert an acausal relation between distinct things. Such a repetition, according to Deleuze, emphasizes the "difference" or uniqueness of each repeated act, "expressing a power peculiar to the

Zufällige Erscheinungen in Macdonalds Videoarbeiten können als Anzeichen einer Verbindung zwischen diskreten Phänomenen gedeutet werden, einer Korrespondenz zwischen inneren geistigen Vorgängen und äußeren Ereignissen. *House* kombiniert auch hier die Erfahrung der Synchronizität mit jener der Dauer. Der einheitliche Fluss des Bands wird kurz nach Beginn der zwanzigminütigen Laufzeit von einem vorüberfahrenden Boot durchbrochen. Ein anderes Boot, das unmittelbar vor Ende des Videos den Bildschirm überquert, wird vom Betrachter als Geschenk begrüßt, als Ereignis, das dem Kontinuum der ewigen Gegenwart ein Gefühl der Ordnung verleiht. Die Illusion der Synchronizität ist das Resultat des Zeitrahmens, in den Macdonald das Werk setzt. Es führt in gewissem Sinne die innere Kontinuität zwischen Natur und menschlicher Wahrnehmung vor, indem es die Erfahrung der Synchronizität und der Dauer in sich fasst.

Das Bemühen, den Verstand für die unvermittelte Präsenz der Erscheinungen zu öffnen und gleichzeitig nach Zeichen der Korrespondenz Ausschau zu halten, wird in *Eclipse* (2000) prägnant dargestellt. Ein Ball kollert und treibt auf einer Wasserpfütze und spielt dabei mit der Reflexion der Sonne, deren glitzerndes Rund er mit dem eigenen Schattenkreis abwechselnd verdeckt und aufdeckt. Das formale Echo der sich überlagernden Kreise verweist nüchtern auf das Band zwischen allen Dingen.

Leibniz' These vom universellen Zusammenhang der Dinge fußt auf der Voraussetzung einer „Erfülltheit der Welt", in der „jeder Körper auf jeden anderen Körper … einwirkt" und „durch dessen Gegenreaktion betroffen wird". Er präsentiert ein Bild der Totalität, jedoch nicht ohne die Möglichkeit des Ablaufs vieler Geschehnisse außerhalb der Grenzen der Vernunft und Kausalität einzuräumen: „Denn da alles erfüllt ist, was alle Materie miteinander verknüpft sein läßt, und da im Erfüllten jede Bewegung nach dem Maße der Entfernung eine Wirkung auf die entfernten Körper ausübt, derart daß jeder Körper nicht nur durch diejenigen beeinflußt wird, die ihn berühren und in gewisser Weise alles, was in ihnen geschieht, in sich spürt, sondern auch durch ihre Vermittlung noch diejenigen spürt, die wiederum jene ersten, von denen er unmittelbar berührt wird, ihrerseits berühren—so folgt daraus, daß diese Mitteilung über jede beliebige Entfernung hinwegreicht."[13]

Obwohl Macdonalds Kunst sich nicht bewusst der Leibniz'schen „Erfülltheit der Welt" verschreibt, stellt sie sich den Konsequenzen, die der freie, durch die allgemeine Wechselwirkung entstehende Zusammenhang der Körper mit sich bringt. Die Wiederholung einfacher

54

existent" that "resists any specification by concepts."[12] Repetition and synchronicity in Macdonald's work thus indicates the elasticity of the phenomenal world and is reconciled with his presentation of duration as a process of grounding perception in the immanence of a lived time. Held between the virtual and the actual, between half-signs of an imagined order and the materiality of immediate happenings, his video work presents perception as a means to live in the palpable world and to sense the possibilities of its meaningful change. It urges the audience to use perception to attain a freer relation with the world beyond the limits of the normative dictated by the idealizing eye.

Notes

1. Carl Gustav Jung, *The Portable Jung*, ed. Joseph Campbell, trans. R. F. C. Hull (London: Penguin, 1957), 518.
2. Ibid.
3. G. W. Leibniz, *G. W. Leibniz's Monadology: An Edition for Students*, ed. and trans. Nicholas Rescher (Pittsburgh: University of Pittsburgh Press, 1991), 66.
4. Ibid., 198.
5. Gilles Deleuze, *Bergsonism*, trans. Hugh Tomlinson and Barbara Habberjam (New York: Zone Books, 1988), 37.
6. Ibid., 32.
7. Ibid., 43.
8. Deleuze, *Essays Critical and Clinical*, trans. Daniel W. Smith and Michael A. Greco (Minneapolis: University of Minnesota Press, 1997), 139.
9. Leibniz, *G. W. Leibniz's Monadology*, 73–74.
10. Ibid., 75.
11. Ibid., 198.
12. Deleuze, *Difference and Repetition*, trans. Paul Patton (New York: Columbia University Press, 1994), 13–14.

Vorkommnisse in seinen Werken lässt sich nicht auf ein verallgemeinertes Identitätsprinzip reduzieren, da diese eine akausale Beziehung zwischen einzelnen Dingen postulieren. Eine derartige Wiederholung akzentuiert laut Deleuze die „Differenz" oder Einzigartigkeit jedes wiederholten Geschehens, sie „drückt eine spezifische Macht des Existierenden aus … die jeder Spezifikation durch den Begriff widersteht".[14] Wiederholung und Synchronizität bezeichnen bei Macdonald also die Elastizität der Erscheinungswelt und vereinen sich mit seiner Darstellung der Dauer als Prozess, der die Wahrnehmung in der Immanenz einer gelebten Zeit verankert. In der Schwebe zwischen Virtualität und Aktualität, zwischen Halb-Zeichen imaginärer Natur und der Materialität des unmittelbar Geschehenden, weisen seine Videos die Wahrnehmung als einen Weg, in der fassbaren Welt zu leben und sich der Möglichkeit bewusst zu sein, sie sinnvoll zu verändern. Sie fordern den Betrachter auf, mithilfe der Vorstellungskraft einen freieren Umgang zu finden mit der Welt, die jenseits der Normen liegt, die das idealisierende Auge diktiert.

Aus dem Englischen übersetzt von Bernhard Geyer.

Anmerkungen

1. Carl Gustav Jung, *Über Synchronizität*, in: *Eranos-Jahrbuch 1951 XX* (Zürich, 1951), S. 283.
2. Ebd.
3. Gottfried Wilhelm Leibniz, *Die Prinzipien der Philosophie oder die Monadologie*, in: *Kleine Schriften zur Metaphysik* (Darmstadt, 1965), S. 443.
4. Leibniz, *In der Vernunft begründete Prinzipien der Natur und Gnade*, in: *Kleine Schriften zur Metaphysik*, S. 417, 416, 417.
5. Leibniz, *Neue Abhandlungen über den menschlichen Verstand* (Leipzig, 1904), S. 521.
6. Leibniz, *Monadologie*, in: *Kleine Schriften zur Metaphysik*, S. 455, 465.
7. Gilles Deleuze, *Henri Bergson zur Einführung* (Hamburg, 2001), S. 53.
8. Ebd., S. 47.
9. Ebd., S. 60.
10. Gilles Deleuze, *Kritik und Klinik* (Frankfurt am Main, 2000), S. 187–188.
11. Leibniz, *Entgegnung auf die in der zweiten Auflage des Bayleschen Wörterbuchs enthaltenen Bemerkungen über das System der vorherbestimmten Harmonie* (Leipzig, 1884), S. 112–113.
12. Leibniz, *Prinzipien der Natur und Gnade*, S. 421.
13. Ebd., S. 417; *Monadologie*, S. 467.
14. Deleuze, *Differenz und Wiederholung* (München, 1992), S. 30.

- Untitled (everythinghappensatonce) 1998
 Ink on paper
 66 x 101 cm

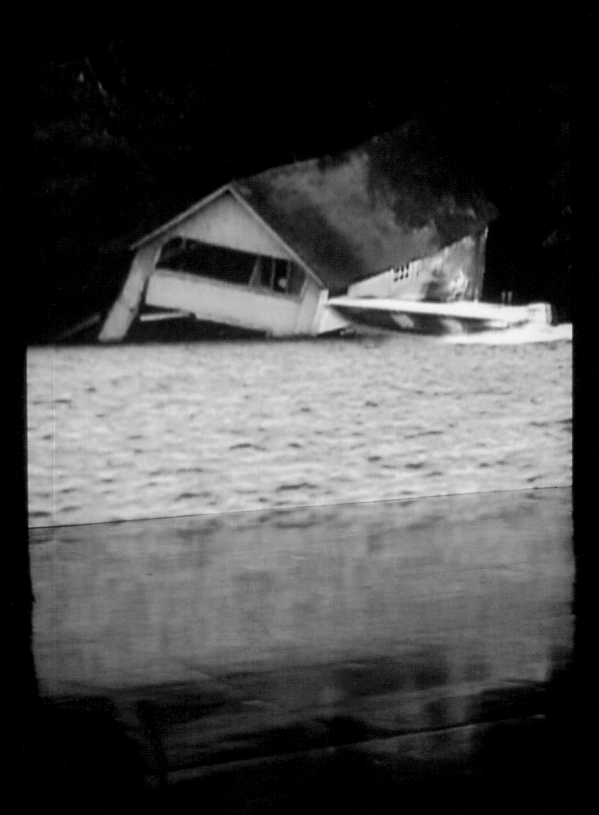

- House (everythinghappensatonce) 1999
Single-channel video projection
19:54 minutes

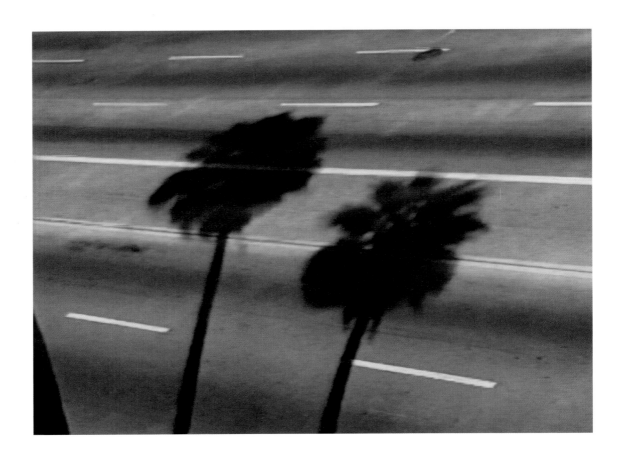

58

- Interval 1997
Single-channel video projection
2:25 minutes

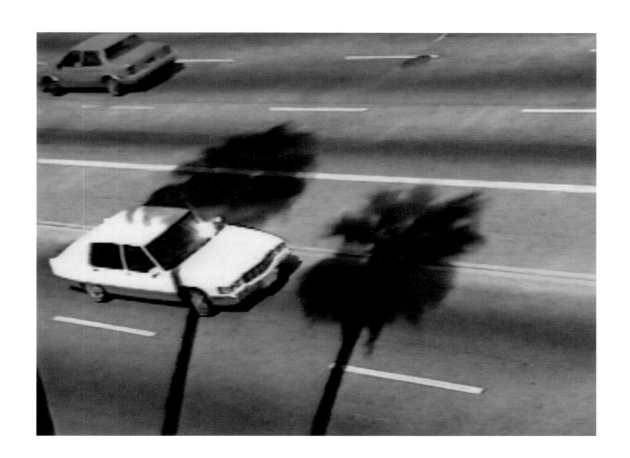

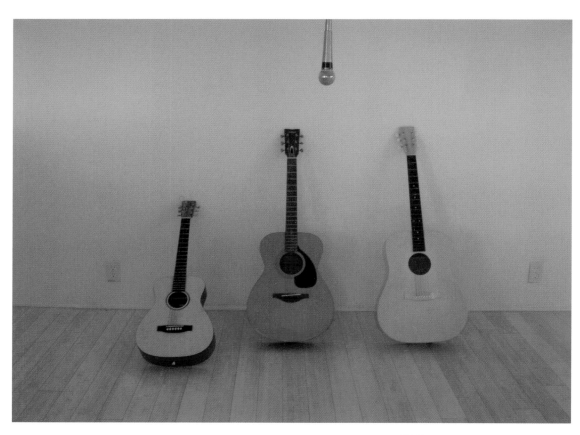

- GAD 2004
Single-channel video projection
1 minute

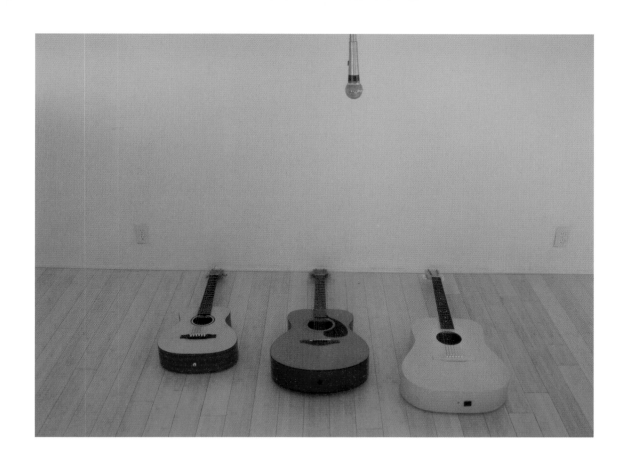

62

- The Shadow's Path 2003
 Single-channel video projection
 9 minutes

- Installation view, Center for Curatorial Studies,
Bard College, Annandale-on-Hudson, New York, 2003

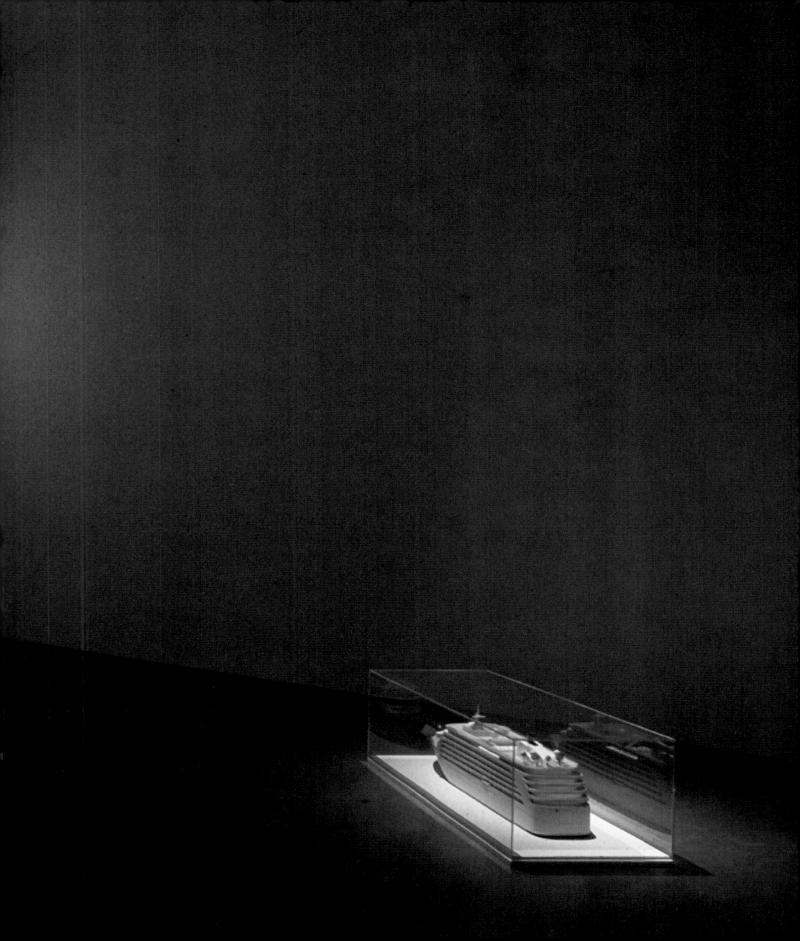

- Three Trucks 2000
 Single-channel video projection
 2 minutes

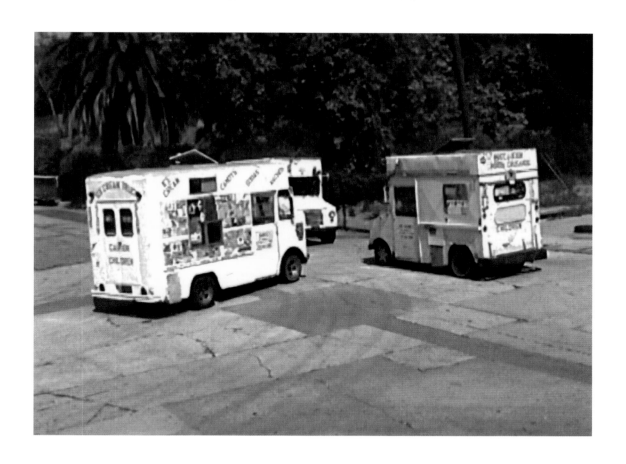

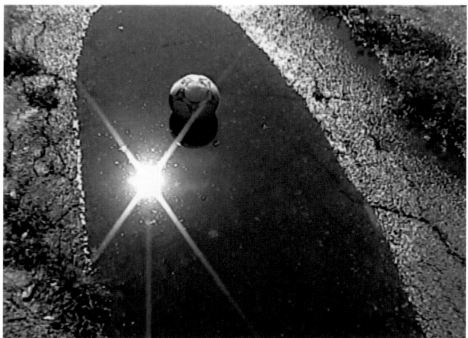

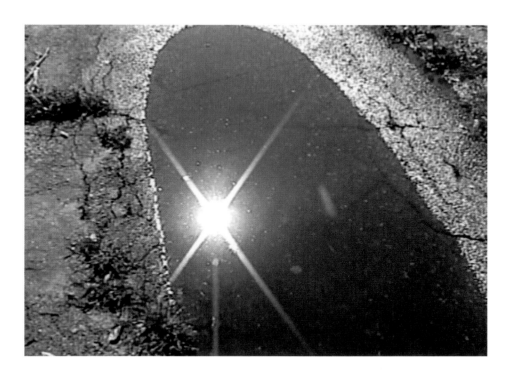

- Eclipse 2000
 Single-channel video projection
 2:25 minutes

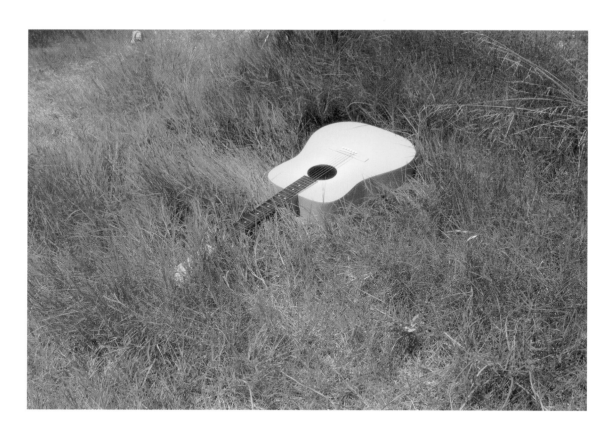

- Some Summer Day 2004
C-prints
Two parts: 60 x 45 cm each

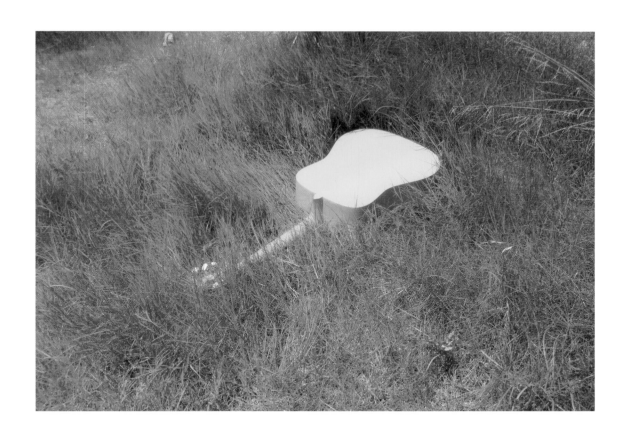

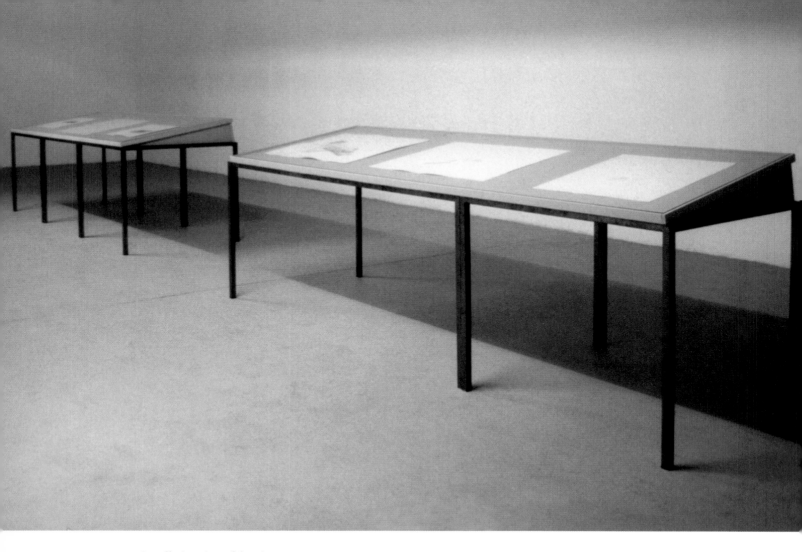

- Installation view of drawings,
 Kunstbunker, Nürnberg, Germany, 2004

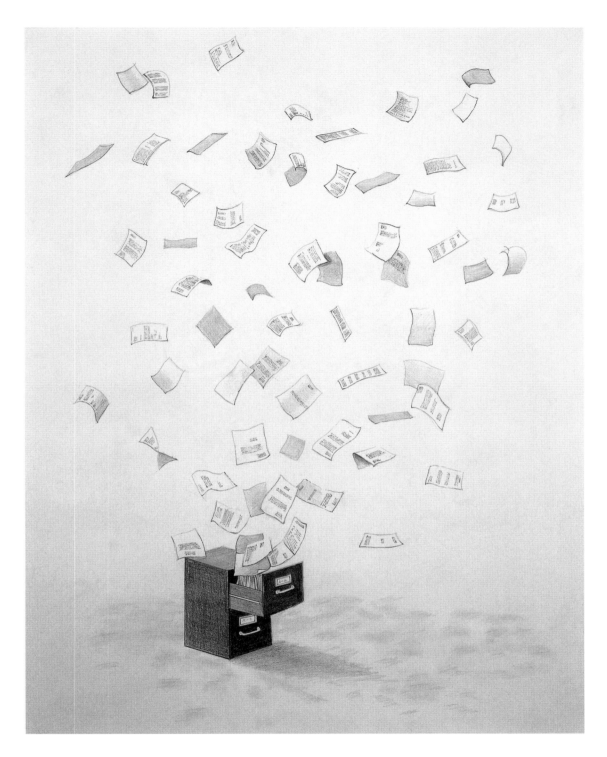

- File Cabinet 2002
Graphite on paper
48,5 x 63,75 cm

- Untitled (Reflected Buildings) 2004
 Ink on paper
 Three parts: 75 x 50 cm each

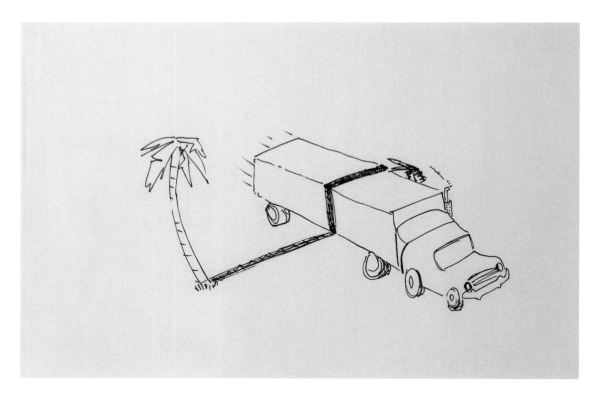

- Untitled (truck and shadow) 1997
 Ink on paper
 76 x 51 cm

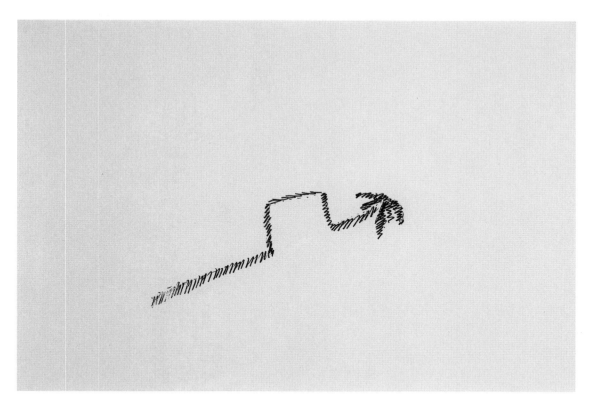

- Untitled (shadow) 1997
 Ink on paper
 76 x 51 cm

78

- Night Traffic 2004
 Ink on paper
 75 x 50 cm

- Untitled (man at desk) 2001
 Graphite on paper
 64,5 x 30 cm

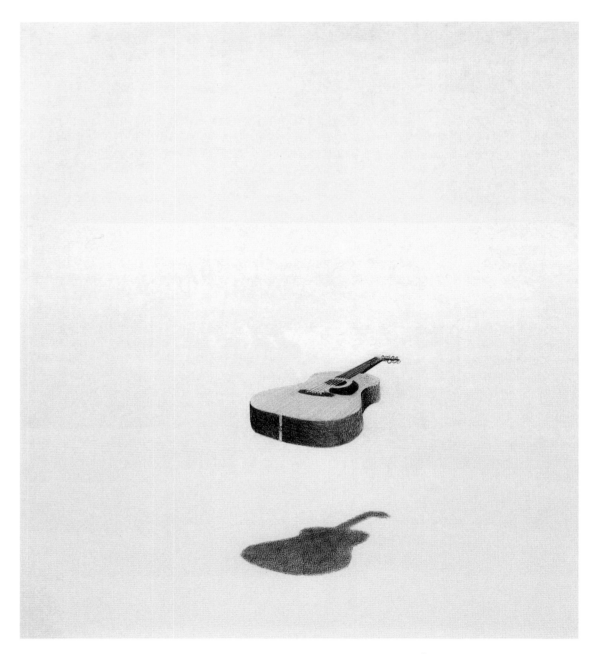

- Falling Guitar 2003
Graphite on paper
Two parts: 49 x 55 cm each

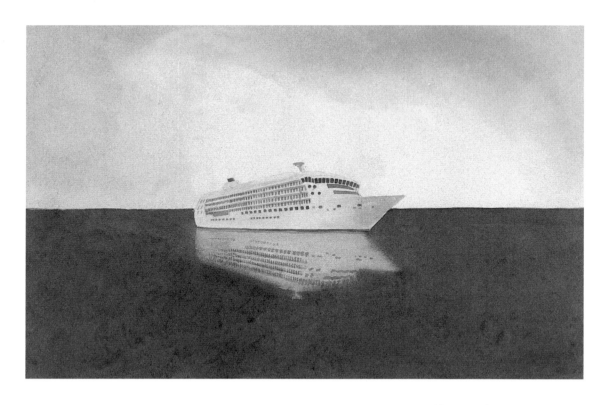

82

- World Reversal 2003
 Ink on paper
 Three parts: 50 x 38 cm each

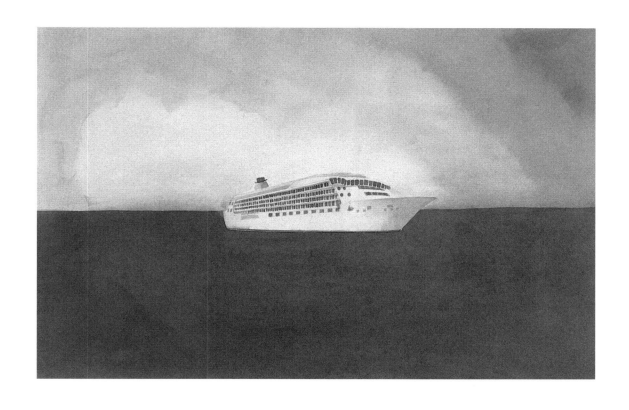

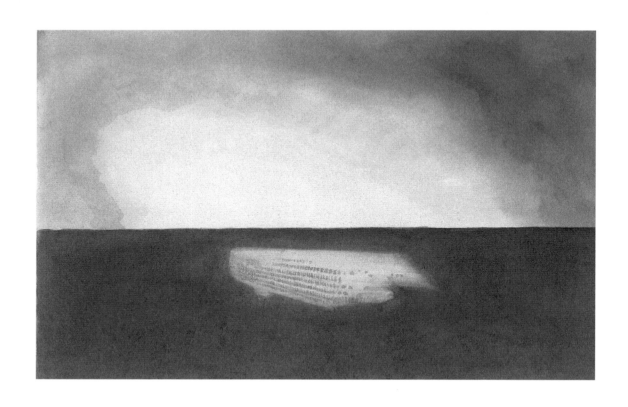

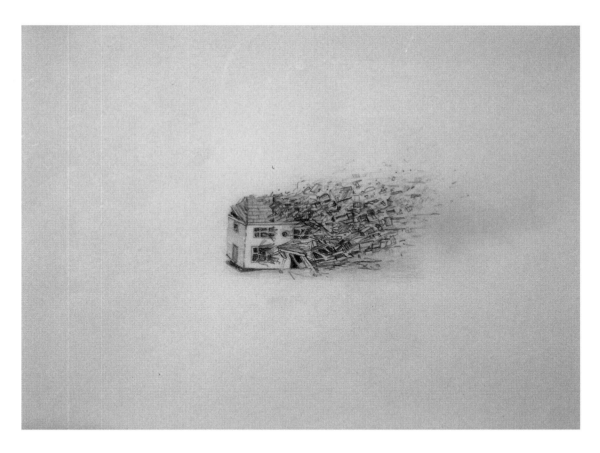

- Untitled with Wind 1999
 Graphite on paper
 75 x 50 cm

- Untitled 2001
 Ink on paper
 Two parts: 75 x 50 cm each

- Canoe 2003
 Ink on paper
 50 x 40 cm

88

- American Nocturne (Richard Pryor) 2005
 Ink and gouache on paper
 74 x 56 cm

what *is*

Was *ist*

Ann MacDonald

Euan Macdonald moves through media and content like a conceptual flâneur, resisting both familiarity and complacency. Macdonald himself is something of a global citizen: born in Edinburgh and raised in the United Kingdom until the age of fourteen, he moved with his family to Canada, where he completed his art education. Currently, Macdonald lives in Los Angeles, but his exhibition roster demands that he travel frequently. In keeping with his nomadic art practice, Macdonald moves between sculpture, drawing, and video, working with and transforming a variety of familiar subjects while deftly evading the pitfalls of didacticism.

A recent example of Macdonald's explorations involved Toronto's CN Tower, which defines the city's skyline. Macdonald's *The Tower* (2004) is his replica of the top twenty-five feet of the CN Tower that he installed in the downtown park of the Toronto Sculpture Garden. He had *The Tower* built by a film-set construction company and presented it as though it was sticking up through the earth with the majority of its form buried beneath.

The actual CN Tower occupies a place deep in the psyche of many Torontonians. Although the structure is now an everyday sight, it has grown as a symbol for the city (beyond its recognition as an engineering feat as one of the tallest towers in the

Vertrautheit und Selbstgefälligkeit vermeidend, schlendert Euan Macdonald wie ein Flaneur des Konzeptionellen durch Medien und Inhalte. Macdonald ist so etwas wie ein Weltbürger: Geboren in Edinburgh und aufgewachsen in England, zog er im Alter von 14 Jahren mit seiner Familie nach Kanada, wo er seine Ausbildung abschloss. Derzeit lebt Macdonald in Los Angeles. Sein dichter Ausstellungs-Kalender verlangt jedoch, dass er viel reist. Es passt zu seinen nomadischen Gewohnheiten, dass Macdonald sich zwischen Skulptur, Zeichnungen und Video-Arbeit hin und herbewegt, dass er eine Vielfalt von vertrauten Themen aufgreift, verwendet und verändert und es dabei geschickt vermeidet, schulmeisterhaft zu wirken.

Ein neuestes Beispiel für Macdonalds Erkundungen hat mit Torontos Fernsehturm zu tun, der die Skyline der Stadt bestimmt. Macdonald's *The Tower* (2004) ist eine exakte Kopie der obersten 25 Fuß hohen Spitze dieses CN-Turms, die im Skulpturgarten Torontos aufgestellt wurde. Er ließ den *Tower* von einer Konstruktionsfirma für Film-Sets errichten und präsentierte ihn so, als ob er – zum größten Teil verschüttet – nur mit seiner obersten Spitze aus dem Erdboden herausragen würde.

Der eigentliche CN-Turm, obwohl mittlerweile ein alltäglicher Anblick, nimmt in der Psyche der Bewohner

- CN Tower (futuristic view) 2004
 C-print
 17,75 x 10,5 cm

world). The telecommunications hub was completed in 1976—a time when the city of Toronto strove for world-class-city status. A signifier of imagination and optimism, the CN Tower can also be recognized by a sense of bravado in tourist brochures that competes with Torontonian self-identity and an ambiguous attitude toward such ambition. The sight of Macdonald's tower, submerged and annihilated, is a clever and iconoclastic jab at such hubris.

While engaged in building the monumental CN Tower, its architects marveled at its scale and wondered about "its destructive range if toppled, the tower arising from a sea of broken airplanes, the tower upside down penetrating the depths as opposed to the sky." Ned Baldwin, one of the architects, went on to ask: "Will it even be recognizable for what it is when brought again to ground level? Does it matter? The creative work here is in the very idea."[1]

The Tower was inspired by a well-known scene in the 1968 science-fiction film *Planet of the Apes* that featured a half-buried Statue of Liberty. The genre of science fiction sensationalizes space travel but also explores the ethical implications of human technological advancement and control over nature. *Planet of the Apes* was produced during the Cold War, when Earth remained under the constant threat of atomic annihilation. The movie's tone coupled Charlton Heston's over-the-top acting with a socio-psychological analysis of modern Western culture. Like *Planet of the Apes*, Macdonald's *The Tower* invites absurdist speculation into geological shifts and the temporality of civilizations. It is perhaps this acute awareness of impermanence that enabled Macdonald to step back and consider the bigger picture.

This tendency toward comic absurdity is reflected in the *American Nocturne* drawings (2005), which depict melancholic night scenes in anonymous urban landscapes. A single lit billboard is

Torontos einen wichtigen Platz ein und ist zu einem Symbol für die Stadt geworden. Dieses Telekommunikationszentrum wurde 1976, also zu einer Zeit errichtet, als Toronto sich um den Status einer Weltstadt bemühte. Der CN Turm wurde zum Symbol für Phantasie und Optimismus und wird in Touristenbroschüren für seinen Mut gelobt, der sich mit dem Selbstbewusstsein der Bewohner Torontos misst, und man kommentiert die vielschichtige Haltung, die man solchen Ambitionen gegenüber hat. Macdonalds Turm, verschüttet und zerstört, ist eine kluge und ikonoklastische Spitze gegen solche Anmaßung.

Während sie den CN-Turm konstruierten, machten sich die Architekten des monumentalen Gebäudes staunend Gedanken über seine Höhe und fragten sich, „was für zerstörerische Ausmaße ein Einsturz des Turmes annehmen würde". Sie spekulierten „über einen Turm, der sich aus einem Meer zerbrochener Flugzeuge erheben würde, und stellten sich den Turm vor, wie er, auf den Kopf gestellt, in die Tiefen er Erde eindringt, anstatt in den Himmel zu ragen". Ned Baldwin, einer der Architekten, fragte weiter: „Würde der Turm, auf Bodenebene heruntergeholt, überhaupt noch als das erkenntlich sein, was er ist? Ist das von Bedeutung? Die gestalterische Arbeit liegt hier in ebendieser Idee."[1]

The Tower wurde von einer gut bekannten Szene im Film *Planet der Affen* aus dem Jahr 1968 inspiriert, in der eine fast völlig verschüttete Freiheitsstatue zu sehen ist. Sciencefiction liebt sensationelle Raumfahrts-Themen, untersucht aber auch die ethischen Auswirkungen, die der technische Fortschritt und Kontrolle über die Natur auf die Menschheit haben. *Planet der Affen* entstand während des Kalten Krieges, als die Welt ständig von atomarer Vernichtung bedroht war. Der Stil des Filmes verbindet Charlton Heston's übertriebene schauspielerische Leistung mit einer sozial-psychologischen Analyse moderner westlicher Kultur. Wie der Film *Planet der Affen* fordert auch Macdonalds *The Tower* zu absurden Spekulationen

- American Nocturne (Bill Hicks) (detail) 2005
 Ink and gouache on paper
 74 x 56 cm

90

- Twin File Cabinets 2004
 Ink on paper
 76 x 101,5 cm

prominent in each scene. Instead of manufacturing desire for excessive levels of consumerism, Macdonald's billboards offer simple quotes from various American comedians of the 1970s and 80s. The acerbic minds of the likes of Lenny Bruce, Bill Hicks, Andy Kaufman, and Richard Pryor were tapped. These comics were popular social critics of American culture and were often censored (or in Bruce's case, arrested) for their willingness to break taboos and question mainstream cultural mentality regarding drugs, sex, religion, racial tolerance, national public policy, and foreign relations. Undermining the status quo, each of these men brought cultural problems to popular attention. Hicks's definition of a comic might easily be applied to Macdonald: "He's the antithesis of the mob mentality. The comic is a flame ... toppling idols no matter what they are. He keeps cutting everything back to the moment."[2]

The *American Nocturne* series offers quiet settings in which the usual noise of urban life has been excluded. The thoughts of comic visionaries replace the usual mechanisms of the capitalist machine and allow space for rumination. The works recognize and accept the chaos and overstimulation of urban life but offer an alternative, recalling the words of John Cage: "Our intention is to affirm this life, not to bring order out of chaos nor to suggest improvements in creation, but simply to wake up to the very life we're living, which is so excellent once one gets one's mind and one's desires out of its way and lets it act of its own accord."[3]

über geologische Veränderungen auf und fördert das Nachdenken über die Vergänglichkeit von Zivilisationen. Vielleicht ist es gerade dieses akute Bewusstsein der Vergänglichkeit, die es Macdonald ermöglichte, auf Abstand zu gehen und sich ein umfassenderes Bild zu machen.

Macdonalds Neigung zum Komischen wird in den *American-Nocturne*-Zeichnungen deutlich (2005), die melancholische Nachtszenen in anonymen Stadtlandschaften beschreiben. In jedem Bild gibt es eine hell beleuchtete Werbewand, die heraussticht. Statt Verlangen nach immer größerem Konsum produzieren zu wollen, enthalten Macdonalds Werbeflächen kurze Zitate amerikanischer Humoristen der Siebziger- und Achtzigerjahre. Er bedient sich des ätzenden Verstandes eines Lenny Bruce, Bill Hicks, Andy Kaufman und Richard Pryor. Diese Komiker waren populäre Sozialkritiker amerikanischer Kultur und wurden oft zensuriert (oder im Falle von Bruce auch verhaftet), weil sie bereit waren, Tabus zu brechen und die allgemeine öffentliche Geisteshaltung in Sachen Drogen, Sex, Religion, Rassen-Diskriminierung, nationaler öffentlicher Ordnung und außenpolitischer Beziehungen in Frage zu stellen. Jeder dieser Männer brachten kulturelle Missstände ins öffentliche Bewusstsein, indem er den Status Quo unterminierte. Hicks Definition eines Komikers ist auch auf Macdonald anwendbar: „ Er ist die Anti-These zur Mentalität der Massen: Der Komiker ist wie eine Flamme ... Er stürzt Idole, egal, wer oder was sie sind. Er reduziert alles auf den Augenblick."[2]

Die Serie *American Nocturne* zeigt stille Szenen, weit entfernt vom üblichen Lärm des städtischen Lebens. Die Gedanken der humoristischen Visionäre ersetzen die sonst üblichen Mechanismen der kapitalistischen Maschinerie und geben uns Raum zum Nachdenken. Macdonalds Arbeiten erkennen und akzeptieren das Chaos und die Über-Stimulierung städtischen Lebens,

- Bruce Nauman, Violin Tuned to D E A D 1969
 Videotape, black and white, sound
 60 minutes to be played continuously
 Courtesy Electronic Arts Intermix (EAI),
 New York

- You'll Fly Away 2004
Ink on paper
40,5 x 30,5 cm

In Macdonald's video work *GAD* (2004), three guitars lean against the wall and, one by one, slide down the wall and hit the floor, striking one of the three chords represented in the title. From left to right, G-A-D, each chord compounds the last, creating an auditory and communal final breath. Macdonald's work is in dialogue with Bruce Nauman's *Violin Tuned to D E A D* (1969), in which Nauman repeatedly played together all four strings of a violin tuned to the notes D-E-A-D for sixty minutes. The repetition of sound and action in the video, shot with the camera on its side and featuring Nauman stationary but with his back to the camera, elicits a sense of frustrated anticipation in the viewer. Macdonald, in his typical fashion, took a few steps back from this idea by removing the player. He has also remarked that "Gad" is a regional American pronunciation of "God," evoking the artist's role of the Almighty as he determines the moment of collapse for each guitar—an oblique reference to the religious right-wing determinism of moral good and economic success based on one's standing with God's favor.

File Cabinet (2004) is a silent video in which the low-tech apparatus meant to facilitate bureaucratic order has been corrupted. A file cabinet sits with its top drawer mysteriously open; after several

- File Cabinet 2004
Single-channel video projection
5 minutes

aber sie bieten eine Alternative an, die an John Cage's Worte erinnert: „Wir haben die Absicht, dieses Leben zu bejahen, nicht aus Chaos Ordnung zu machen oder Verbesserungen an der Schöpfung anzuregen, sondern vielmehr zu genau dem Leben zu erwachen, welches wir leben. Dieses Leben, das so wunderbar ist, sobald es gelingt, Verstand und Sehnsüchte beiseite und Leben einfach Leben sein zu lassen."[3]

In Macdonalds Video *GAD* (2004) lehnen drei Gitarren an einer Wand. Eine nach der anderen gleitet ab und schlägt auf dem Boden auf. Jeweils eine der Saiten, G-A-D (denen das Video seinen Titel verdankt), schlägt an. Von links nach rechts, G-A-D, vermischen sich die Töne miteinander zu einem hörbaren, gemeinsamen letzten Hauch. Macdonalds's Arbeit hält Zwiesprache mit Bruce Nauman's *Violin Tuned to D E A D* (1969), wo Nauman sechzig Minuten lang immer wieder alle vier Saiten einer Geige spielte, die auf die noten D-E-A-D gestimmt waren. Die ständige Wiederholung von Ton und Vorgängen, die mit einer auf die Seite gekippten Kamera aufgenommen sind und die Nauman stehend, aber von hinten zeigen, löst im Zuseher ein Gefühl frustrierter Erwartung aus. Macdonald, in der für ihn typischen Art, tritt von dieser Idee Naumans einige Schritte zurück, indem er den Geigenspieler weglässt. Er weist auch darauf hin, dass das Wort „God" (Gott), wenn mit regionalem amerikanischem Akzent ausgesprochen, wie „Gad" klingt. Dies wieder ruft die Rolle des Künstler in der Rolle des Allmächtigen in Erinnerung, der genau bestimmt, wann welche Gitarre umfällt: Ein verblümter Hinweis auf die rechtsradikale religiöse Verbissenheit, bei der das moralisch Gute und wirtschaftlicher Erfolg als Maßstab dafür gilt, wie sehr man in der Gunst Gottes steht.

Der Stummfilm *File Cabinet* (2004) zeigt die Zerstörung eines einfachen, untechnisches Systems, das eine bürokratische Ordnung ermöglichen sollte. Ein Aktenschrank steht da, seine oberste Lade steht rätselhafterweise offen. Nach einigen Momenten werden die dort eingeordneten Dokumente durch eine unsichtbare Kraft, Stück für Stück, in die Höhe gewirbelt. Die Bewegungen dieser freigeblasenen Papiere werden zu einem improvisierten Tanz der Blätter. Manche der begleitenden Zeichnungen, die Macdonald für *File Cabinet* hergestellt hat, zeigen zwei hohe vertikale Aktenschränke nebeneinander, aus denen Papiere flattern. Diese Bilder erinnern stark an die am 11. September 2001 durch die Anschläge auf das World Trade Center in die Luft geschleuderten Papiere. Die Zerstörung des World Trade Centers, dem Symbol freier Marktwirtschaft und wahrscheinlich Zentrum des intensivsten Glaubens, des Glaubens an die Wirtschaft, setzte

moments, once-constrained sheets of paper are gently and gradually blown free by an unseen force. The movement of the papers takes on a haphazard flow as the documents are freed from their home. The drawings Macdonald made for *File Cabinet* sometimes present tall twin cabinets with escaping contents, reminiscent of the papers falling to the ground immediately following the 9/11 attacks. The collapse of the World Trade Center towers (paradigmatic symbols of a free-market economy and perhaps the locus of the most intense form of faith: economic) upended the arrogant assumption of American infallibility as lives were lost and markets were shut down. The catastrophe of this historic moment still has nonpartisan economists doubtful about the economic security of the United States and, by extension, the security of the global economy.

Macdonald's work transforms the familiar, whether political events, social phenomena, popular movies, earlier works of art, or public monuments. He acknowledges their complexity and value as cultural barometers, transforming them into different incarnations that invite us to consider the recondite connectedness between actuality and illusion.

Notes

1. Ned Baldwin, Baldwin & Franklin Associates, in a statement for *The Tower*, exh. brochure (Toronto: Toronto Sculpture Garden, 2004).
2. Bill Hicks, quoted in John Lahr, *The Goat Boy Rises*, in: *The New Yorker* (1 November 1993).
3. John Cage, *Four Statements on the Dance* (1939), in: *Silence* (Cambridge, Massachusetts: The MIT Press, 1966), 95.

angesichts der Todesopfer und geschlossenen Märkte mit einem Schlag der arroganten Illusion von amerikanischer Unbesiegbarkeit ein Ende. Unabhängige Wirtschaftsfachleute fragen sich immer noch, wie stabil die Wirtschaft der Vereinigten Staaten nach dieser Geschichte-machenden Katastrophe ist und, daraus folgend, wie stabil die Weltwirtschaft.

Macdonalds Arbeit transformiert das uns Vertraute: Politische Ereignisse, soziale Phänomene, populäre Filme, Kunstwerke aus früherer Zeit und öffentliche Monumente. Ihre Vielschichtigkeit und Wertigkeit sind für ihn kulturelle Barometer, denen er die unterschiedlichsten Formen verleiht und mit denen er uns auffordert, die tiefgründige Verbindung von Illusion und Wirklichkeit zu bedenken.

Aus dem Englischen übersetzt von Elisabeth Pozzi-Thanner.

Anmerkungen

1. Ned Baldwin, Baldwin & Franklin Associates, Auszug aus einem Text zu *The Tower*, Broschüre (Toronto: Toronto Sculpture Garden, 2004).
2. Bill Hicks, zitiert in John Lahr, *The Goat Boy Rises*, in: *The New Yorker* (1 November, 1993).
3. John Cage, *Four Statements on the Dance* (1939), in: *Silence* (Cambridge, Massachusetts: The MIT Press, 1966), S. 95.

94

- Man and Shadow 2000
 Ink on paper
 75 x 50 cm

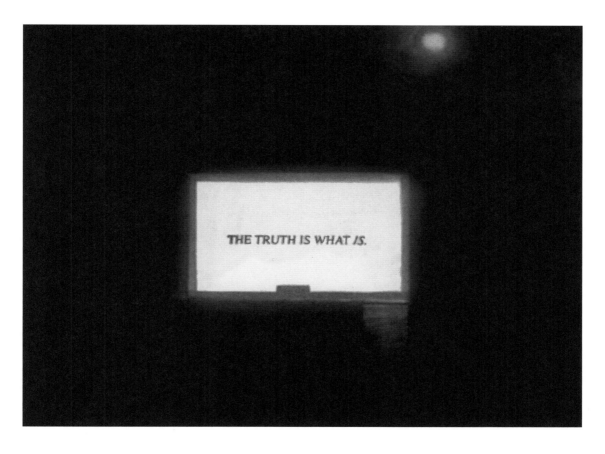

- American Nocturne (Lenny Bruce) (detail) 2005
 Gouache on paper
 74 x 56 cm

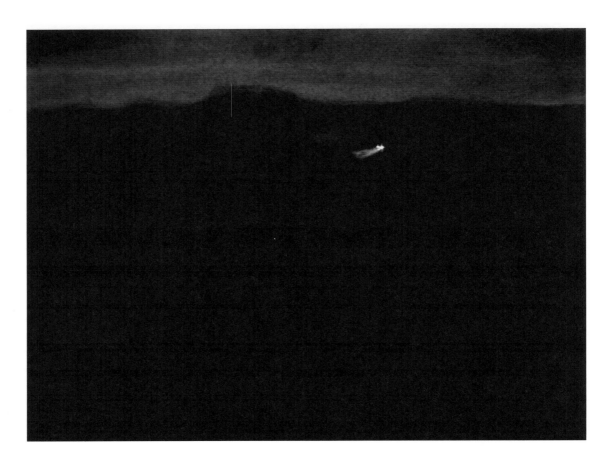

96

- Night Driver 2004
 Ink on paper
 75 x 50 cm

mysterioso: the oneiric work of euan macdonald

Mysterioso: Euan Macdonalds traumhaftes Werk

Giorgio Verzotti

The work of Euan Macdonald can be seen as a radical response to the technological pretentiousness that dominates much artwork today. This pretentiousness has accustomed us to await marvels: these days, in order to see a technologically complex video work or installation, one has to line up, wait one's turn, finally (and reverently) enter a dark room, and then wait. A work by Bill Viola must be experienced with veneration, like witnessing a religious ceremony; upon entering a room to see a work by Doug Aitken, or perhaps a spaceship by Mariko Mori, a miracle is expected. The workings behind these grandiloquent pieces are secret (when not actually protected by patent) and known only to a few hyper-specialists.

Macdonald is not interested in the polemics regarding whether art is "democratic" or the arcane province of a privileged few, but he clearly demonstrates a desire for his work to "radiate," as Elias Canetti would say: to be understood by many because what it contains can be translated into many languages. A point of departure and honor for this artist, who is Scottish-born but resides in Los Angeles by way of Canada, is simplicity. His videos, photographs, and paintings are not difficult to create in the sense that while looking at them, observers are immediately able to understand how they were made, can grasp the creative process, and might even feel stimulated

Euan Macdonalds Kunst kann als radikale Antwort auf all die technologische Überheblichkeit angesehen werden, von der so viele künstlerische Arbeiten heute beherrscht werden. Diese Arroganz hat uns daran gewöhnt, Wunder zu erwarten: Um heutzutage eine Videoarbeit oder eine technisch komplizierte Installation besichtigen zu können, muss man zuerst einmal Schlange stehen, muss warten, bis man an der Reihe ist, um schließlich (und ehrfürchtig) in dunkle Räume eingelassen zu werden – und warten. An eine Arbeit von Bill Viola muss mit Ehrfurcht herangegangen werden, als würde man eine religiöse Zeremonie miterleben. Mit ebensolcher Erwartungshaltung betritt man heilige Hallen, um Arbeiten von Doug Aitken zu sehen oder vielleicht ein Raumschiff von Mariko Mori. Wir erwarten Wunder. Was sich hinter solch großsprecherischen Stücken verbirgt, ist streng geheim (wenn nicht überhaupt patentgeschützt) und nur einigen wenigen Hyper-Spezialisten bekannt.

Macdonald interessiert sich nicht für die Polemik, ob Kunst „demokratisch" ist oder nur ein obskures Territorium für einige wenige Auserwählte. Sein Wunsch, seine Arbeiten „strahlen" zu lassen – wie Elias Canetti sagen würde –, ist klar und deutlich, um vielen verständlich zu sein, weil die Inhalte in viele Sprachen übersetzbar sind. Schlichtheit ist Ehrensache und ers-

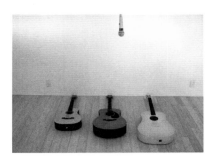

- GAD 2004
 Single-channel video projection
 1 minute

to make their own, demonstrating a non-hierarchical practice like many great artists of the twentieth century.

Critic Adrienne Gagnon has compared Macdonald's videos to visual haiku, acts that are minimal but say everything and need nothing added or taken away. *GAD* (2004) is a striking example: the fixed camera focuses for a few moments on three guitars propped against a wall. Eventually, one after another, the guitars fall to the ground, sliding down due to their precarious positioning. Sounds erupt as each one falls, creating a musical micro-event in which the harmonic effect produced is no less magical because it is elementary. Such simplicity in Macdonald's videos is evident in a minimal use of the camera, whether focused on a single scene or based on simple montage (alternation of scenes announced by fade-outs) or on easily recognizable editing or digital manipulation. Nothing is hidden, and there are no effects whose mechanisms the viewer cannot immediately recognize. One consequence is that the use of time, on which the work is based, becomes equally clear and comprehensible. The simplicity can capture real time, as in a single take, or fictional time, constructed under the viewer's eyes.

Three Trucks (2000) lasts as long as it takes for three ice-cream trucks to slowly converge at

ter Ausgangspunkt für diesen in Schottland geborenen Künstler, der via Kanada nach Los Angeles kam. Es ist nicht schwierig, seine Videos zu produzieren oder seine photographischen Arbeiten und Malereien. Wenn man sie ansieht, versteht man als Betrachter gleich, wie sie entstanden sind. In der unhierarchischen Tradition vieler großer Künstler des zwanzigsten Jahrhunderts kann man den Entstehungsprozess durchschauen und fühlt sich vielleicht sogar angeregt, selbst kreativ zu werden.

Die Kunstkritikerin Adrienne Gagnon hat Macdonalds Videos „visuelle Haiku's" genannt. Minimalgesten, die dennoch alles sagen. Nichts muss hinzugefügt oder weggelassen werden. *GAD* aus dem Jahr 2004 ist dafür ein eindrucksvolles Beispiel: Eine feststehende Kamera fixiert für einige Minuten drei Gitarren, die an eine Wand gelehnt sind. Schließlich fällt eine Gitarre nach der anderen zu Boden; gleitet von der Mauer ab, weil sie schlecht angelehnt war. Im Fallen entstehen Töne; ein musikalisches Mikro-Ereignis entsteht, dessen elementare Qualität dem zauberhaften Effekt keinen Abbruch tut. Die Schlichtheit in Macdonalds Videos wird im minimalistischen Einsatz der Kamera offenkundig, ob auf eine einzelne Szene konzentriert oder in ganz simpler Montage (Szenenänderung wird durch Ausblendungen angekündigt), mit leicht erkennbarem Filmschnitt oder digitaler Manipulation. Nichts geschieht im Verborgenen. Es gibt keine Effekte, deren Mechanismen der Betrachter nicht sogleich erkennen kann. Als Ergebnis wird auch der Einsatz des Faktors Zeit gleichermaßen klar und verständlich. Einerseits kann diese Schlichtheit wie in Zeitlupe Echtzeit einfangen, oder es entsteht unter den Augen des Betrachters fiktive Zeit.

Three Trucks (2000) zeigt drei Eiscreme-Lastwagen, die langsam auf einer Kreuzung aufeinander zufahren und anhalten. Aus jedem der drei Fahrzeuge tönen sentimentale Jingle-Melodien, die sich zu Katzenmusik vereinen. In *Interval* (1997) ist zweieinhalb

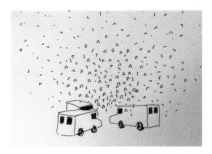

- Untitled (Three Trucks) 2002
 Ink on paper
 71 x 56 cm

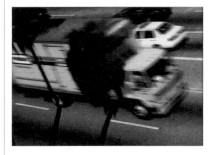

- Interval 1997
 Single-channel video projection
 2:25 minutes

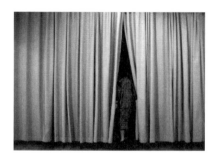

- Healer 2002
Single-channel video projection
5 minutes

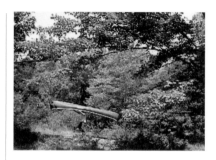

- Natura 2003
Single-channel video projection
3:33 minutes

a crossroads and stop. All three trucks blare out sentimental jingles that commingle in a cacophony. *Interval* (1997) records two-and-a-half minutes of urban traffic on five lanes of a road (presumably in California, given the shadows of two palm trees cast upon the street). *Healer* (2002) shows a stage with an orange curtain, from which an elderly woman emerges; she stands still for several minutes with her arms calmly folded and gaze fixed on the camera, and then simply leaves. The duration of *Snail* (2004) is limited to the time needed for a snail to traverse the terrain across the video camera's frame.

Time is still an important element in *Natura* (2003), but it functions within a (micro)narration and through cuts or black intervals between sequences: a sunset, a night drive, forest, and two characters sitting by a campfire (one burns his foot) and later wandering about while carrying a canoe on their heads. The work ends with a panning shot of the canoe, finally being paddled on a lake; however, it is followed by a tornado, made with the obvious help of digital intervention.

The most complex work in this sense is *House (everythinghappensatonce)* (1999). The fixed scene shows a house on the verge of collapse, about to completely crumble into the river it faces. Here real time is "told" by the water flowing downstream,

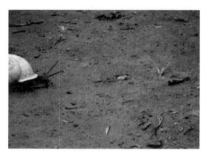

- Snail 2004
Single-channel video projection
5 minutes

Minuten lang städtischer Verkehr auf einer fünfbahnigen Autobahn aufgenommen. Zwei Palmen, die ihre Schatten auf die Straße werfen, lassen darauf schließen, dass es sich wahrscheinlich um Kalifornien handelt. *Healer* (2002) zeigt eine alte Dame, die vor einem orangeroten Bühnenvorhang erscheint. Mehrere Minuten lang steht sie mit verschränkten Armen ganz still da und schaut in die Kamera. Dann geht sie einfach weg. Der Videofilm *Snail* (2004) dauert so lange, wie eine Schnecke braucht, um das Terrain zu durchqueren, das von der stillstehenden Kamera eingefangen ist.

In der (Mikro-)Erzählung *Natura* aus dem Jahr 2003, ist Zeit, die in schwarzen Szenen-Intervallen und Filmschnitten deutlich wird, ein wesentliches Element: Ein Sonnenuntergang, eine nächtliche Autofahrt, Wald, zwei Personen an einem Lagerfeuer (einer verbrennt seinen Fuß). Später sieht man die beiden das Kanu auf ihren Köpfen tragen. Das Stück endet mit einem Kameraschwenk über das Kanu, das endlich über den See gerudert wird. Vorangetrieben jedoch durch einen Wirbelsturm, der ganz offensichtlich digitalen Ursprung hat.

Das komplizierteste Werk in diesem Bereich ist *House (everythinghappensatonce)* (1999). Man sieht ein vom Einstürzen bedrohtes Gebäude, das dabei ist, in den Fluss zu bröckeln, an dessen Ufer es steht. Hier wird die Echtzeit vom Wasser „erzählt", das flussabwärts fließt. Ein Motorboot kommt vorbei, und die Äste eines Baumes bewegen sich im Wind über dem Haus. Diese Mikro-Ereignisse fungieren als Rahmen, fast wie eine Bühne, wie eine Erklärung für eine sich über viel längere Spannen entfaltende Zeit, bis das Haus tatsächlich einmal unter der Last der Schwerkraft zusammenbrechen wird. Dieser Zeitrahmen sprengt das unmittelbare Erleben des Ereignisses. Der Künstler lässt es uns einfach intuitiv erahnen. Und da die Intuition sich der Idee nähert, dass es sich dabei um etwas

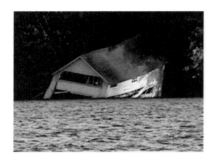

- House (everythinghappensatonce) 1999
Single-channel video projection
19:54 minutes

through which a motorboat passes, and by tree
branches above the house that sway in the wind.
However, these micro-events act as a frame, almost
as a stage, for the unfolding and explication of
a much longer but no less effective time, namely
the time that the house will take to collapse defini-
tively under the force of gravity. This time frame
transcends the direct experience of the event, and
so the artist allows it to be purely intuited. And since
the intuition ends up approaching the idea of an
unpredictable, potentially infinite duration, it suf-
fices for him to prolong the video experience to
just under twenty minutes.

The clarity of his intentions and his work on
time lead one to think that Macdonald approaches
video with an analytic stance that probes the medium's
expressive potential. Without fear of exaggeration,
we might define this intention as conceptual. It is
also found in his drawings, in which the artist often
presents sequences of images that gradually are
transformed from one thing into another through
permutations of graphic signs (and in this case the
artist reaches small heights of virtuosity).

However, the term "conceptual" is introduced
with the admonition that the artist's attention is
not directed so much at signs as such—that is, to
components of linguistic protocols that are gradual-
ly taken into consideration in their basic components
—but rather at the significance of images. An image
can be intended as a system of connotative signs,
a system laden with meaning to the point where it
becomes polysemous, and it is precisely in this
polysemy that the artist is interested. To use a more
appropriate term, we could say that Macdonald is
interested in the constituent ambiguity of images,
such that they indicate and reveal reality at the same
time that they construct and mystify it.

If there is a dialectic relationship between
reality and its visual representation, in which the
second term achieves a certain degree of autonomy,

von unvorhersehbarer Dauer, vielleicht sogar unend-
licher Dauer handelt, genügt es ihm, den Videofilm
nach weniger als 20 Minuten zu beenden.

Die Klarheit seiner Intention sowie seine Arbeiten
über „Zeit" lassen vermuten, dass Macdonald mit
einer analytischen Haltung an Videofilm herangeht,
um die Ausdrucksmöglichkeiten dieses Mediums zu
untersuchen. Ohne Angst vor Übertreibung können
wir diese Absicht als konzeptionell bezeichnen. Sie
findet sich auch in seinen Zeichnungen wieder, die er
oft als Bilderserie präsentiert. Bilder mutieren durch
Veränderung der graphischen Zeichen von einer Sache
in eine andere. (Der Künstler erreicht hier kleine Höhe-
punkte der Virtuosität).

Der Ausdruck „konzeptionell" wird jedoch mit der Ein-
schränkung eingesetzt, dass die Aufmerksamkeit des
Künstlers nicht so sehr auf die Zeichen als solche
gerichtet ist – das heißt auf Komponenten linguistischer
Protokolle, die Stück für Stück in ihren grundsätzlichen
Elementen untersucht werden –, sondern vielmehr auf
die Aussagekraft der Bilder. Ein Bild kann als ein
System konnotativer Zeichen gedacht sein, ein System
so bedeutungsschwer, dass es mehrdeutig wird. Es ist
genau diese Vielschichtigkeit, an der der Künstler in-
teressiert ist. Um einen besseren Terminus zu ver-
wenden, könnte man sagen, dass Macdonald an der
grundlegenden Mehrdeutigkeit von Bildern interes-
siert ist, die auf Realität hinweisen und diese offen-
baren, während sie sie gleichzeitig konstruieren
und mystifizieren.

Wenn es eine dialektische Beziehung gibt zwischen
Realität und ihrer visuellen Darstellung, wobei letztere
ein gewisses Maß an Autonomie erreicht, untersucht
Macdonald diese Dialektik. Er zeigt uns, wie leicht
eine Bedeutung „weggleitet" (Nietzsche würde sagen,
wegrollt, auf das X zu, das Unbekannte), genau in
dem Moment, wenn wir sie in Besitz nehmen wollen.
Um diese Enthüllungsarbeit zu leisten, muss man die
Faszinationskraft der Bilder, ihr „Geräusch", so weit
wie möglich dämpfen. (Wohingegen Videokunst, die
mit Hilfe von Spitzentechnologie entsteht, sich dieser
Faszinationskraft hemmungslos bedient). Macdonald
entscheidet sich für Schlichtheit.

Durch die Einfachheit in der Struktur wird die Kom-
plexität der Ideen deutlich gemacht, die dramatische
Dynamik des Sujets inmitten der Welt, und der Drang,
dies zum Ausdruck zu bringen. Wir sprachen von
Haiku. Ich möchte hinzufügen, dass Macdonalds Prä-
missen (ob Bild- oder Tonaufnahme, Zeichnung, Skulp-
tur, Photographie oder Malerei) immer geistreich sind:

- File Cabinet 2004
Single-channel video projection
5 minutes

Macdonald investigates this dialectic, and he shows us how easily meaning "slides" (rolls away toward "X," the unknown, Friedrich Nietzsche would say) precisely at the moment we take possession of it. To undertake this work of revelation, it is necessary to muffle as much as possible the images' power of fascination, their "noise" (which video art requiring advanced technology feeds off of without restraint). Macdonald chooses simplicity.

But it is simplicity of structure that serves to introduce the complexity of ideas, which concern the dynamics of the subject being in the world and its need to express that. I mentioned haiku, and I might add that Macdonald's propositions (whether recorded, drawn, sculpted, photographed, or painted) are characterized by their wit: often an amusing and apparently innocuous verbal expression in reality conveys a hidden and disturbing meaning that comes from the unconscious. Macdonald's witticisms are disquieting because they implicitly touch upon our alienation, our incapacity to give an unambiguous name to things and thus to dominate them. And this disquietude is all the greater since we are aware of the things that elide this regime of nomination (and domination), as the images with which we represent them are elusive, however precise they may be.

In his work, Macdonald illustrates how images betray us, how they avoid full and unique meaning, how they impede the logical constructions that should orient us in the world. The dialectic in which the artist is interested then becomes one that links the real to the unreal or surreal. At times, the latter bursts in; in *File Cabinet* (2004), a fixed camera records a file cabinet, the top of its two drawers open, against a bare wall. After a few moments, sheets of paper (that should be judiciously filed inside) flutter out, flying away in fluctuating quantities. In *Hammock* (2000), a figure stretched out in a hammock rocks with increasing speed and

Oft sind sie eine amüsante und scheinbar harmlose Äußerung, die in Wirklichkeit eine verborgene und beunruhigende Wahrheit transportiert, die aus dem Unterbewussten kommt. Macdonalds geistreiche Gesten sind deswegen so beunruhigend, weil sie ganz bewusst auf unser Entfremdetsein Bezug nehmen, auf unsere Unfähigkeit, Dinge klar beim Namen zu nennen und damit zu beherrschen. Unsere Unruhe ist umso größer, da wir wissen, welches die Dinge sind, die sich diesem Regime der Namensnennung (und Beherrschung) entziehen. Denn die Bilder, mit denen wir sie darstellen, sind flüchtig; so präzise sie auch sein mögen.

Macdonald illustriert in seinen Arbeiten, wie uns Bilder täuschen können; wie sie klaren und eindeutigen Begriffsinhalten ausweichen; wie sie die logische Auslegung verhindern, die uns in der Welt Orientierung geben sollte. Die Dialektik, an der der Künstler interessiert ist, verbindet Realität mit dem Irrealen oder Surrealen. Manchmal bricht letzteres über uns herein: In *File Cabinet* (2004) nimmt die stehende Kamera einen Aktenschrank auf, der gegen eine leere Wand gelehnt ist. Eine der beiden Laden steht offen. Nach einigen Minuten flattern Papiere heraus (die eigentlich ordentlich archiviert bleiben sollten) und fliegen in großer Menge und mit steigender Geschwindigkeit davon. In *Hammock* (2000) liegt jemand in einer Hängematte und schaukelt darin immer schneller und höher, bis es zu einer Serie von vollständigen Umdrehungen kommt, ohne dass der Schaukelnde jedoch herausfällt. In *Brakestand* aus dem Jahr 1998, wird der Motor eines Autos angeworfen. Das Auto fährt aber nicht los. Es bleibt stehen. Reifen kreischen, und eine Menge Rauch entsteht. Das Gekreische der Reifen und die Rauchentwicklung wiederholen sich immer wieder, 15 Minuten lang. In dieser Installation wird der Film in den tatsächlichen Ausmaßen des Autos auf die Wand projiziert und macht die Szene damit realistischer und absurder. Ob mit oder ohne Veränderungen durch Filmschnitt, Macdonalds Videos zeigen uns immer, wie leicht sich Alltägliches in ein traumähnliches

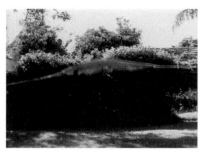

- Hammock 2000
Single-channel video projection
2 minutes

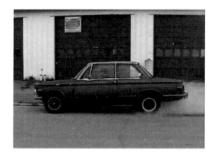

- Brakestand 1998
Single-channel video projection
15 minutes

height until he makes a series of complete revolutions without ever falling out. In *Brakestand* (1998), a car is started with its gas pedal fully engaged but stands still, its rear tires producing a great screech and a lot of smoke. The screech and smoke seamlessly loop for fifteen minutes; in its installation, the image is projected at the scale of the actual car, thus making the scene more realistic and therefore more absurd.

With or without the intervention of editing, Macdonald's videos show us how easily something ordinary can be turned into its oneiric opposite or something truly extraordinary. More precisely, I would say that his video sequences focus on an image or action, an ordinary object or everyday gesture, that reach a point of transcendence, becoming a metaphor for something else, for a further dimension, an otherness.

As the artist himself described it, *Mysterioso* (2003) has a film-noir air about it. Set in a billiard room, the work features close-up shots of a player meticulously chalking his pool cue, as well as of one red and one white ball on a green pool table. The close-ups, however, prevent the viewer from taking in the entire table. In the silence of the room, the alternation between details of the cue and the balls exploits the allure of the suspended atmosphere typical of so many detective films. The close-range details of the balls isolated against the green field, thus "abstracted" from context, allude instead to the movement of the planets, which seem replicated here as in an orrery, a didactic model of the solar system. The artist suggests that everything can have other meanings, explicit or implicit. The woman in *Healer* can be seen in a completely different light if we know that the woman featured in the work is an actual healer who is accustomed to laying hands on the bodies of the sick and emitting her psychic energy.

In what is perhaps Macdonald's most beautiful video, *Eclipse* (2000), a black-and-white soccer

102

Gegenteil verwandeln kann oder in etwas wahrhaft Außergewöhnliches. Genauer gesagt, die Video-Sequenzen konzentrieren sich auf ein Bild oder eine Handlung, einen bekannten Gegenstand oder eine alltägliche Geste, die an die Grenzen der Transzendenz stoßen und zur Metapher werden für eine neue Dimension, ein Anderssein.

Mysterioso (2003) hat, wie der Künstler selber meint, etwas von einem Film Noir an sich. Der Film zeigt in Nahaufnahme einen Billardspieler, der in einem Billardsaal mit akribischer Genauigkeit seinen Billardstock mit Kreide einreibt; zeigt eine rote und eine weiße Kugel auf dem grünen Filz des Tisches. Die Nahaufnahme hindert den Beobachter jedoch daran, den ganzen Tisch zu sehen. Die Kugeln rollen auf Ziele zu, die wir nicht erkennen können. Die Stille des Raumes, die Details des Billardstocks und der Kugeln versetzen uns in die typische spannungsgeladene Atmosphäre eines Kriminalfilms. Die in der Nahaufnahme überdeutlichen Einzelheiten der Kugeln, die sich vom grünen Filzuntergrund abheben und somit aus ihrem Kontext „abstrahiert" werden, lassen an Planetenbewegungen denken, repliziert wie in einem mechanischen Modell des Sonnensystems. Der Künstler meint, dass jedes Ding unterschiedliche Bedeutungen haben kann, eindeutige und implizierte. Wir betrachten die alte Dame in *Healer* mit ganz anderen Augen, wenn wir wissen, dass es sich tatsächlich um eine Heilerin handelt, die Kranken ihre heilenden Hände auflegt und ihre Energie in sie einströmen lässt.

Im vielleicht schönsten Videofilm, den Macdonald geschaffen hat, *Eclipse* (2000) sieht man, von oben aufgenommen, einen schwarz-weißen Ball in einer ovalen Pfütze schwimmen. Die Strahlen der Sonne werden vom Wasser widergespiegelt, direkt in das Auge der Kamera hinein. Ziellos rollt der Ball langsam auf dem Wasser, manchmal blockiert er die Sonnenreflexion. Schließlich verschwindet der Ball aus unserem Blickfeld. Das Video ist nur zweieinhalb Minuten lang,

- Mysterioso 2003
Single-channel video projection
2:30 minutes

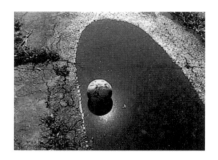

- Eclipse 2000
Single-channel video projection
2:25 minutes

ball, shot from above, floats in an oval puddle that reflects the sun into the camera's lens. The ball slowly meanders and rotates on the water, occasionally blocking the sun's reflection and eventually drifting off-screen. The video lasts only two-and-a-half minutes, but while observing this micro-event, which has no apparent meaning, it becomes impossible not to think of a solar eclipse and other movements of celestial bodies.

For *The Tower* (2004), Macdonald created an outdoor sculpture, but the difference in visual language and scale changed nothing about his intentions or, more importantly, the significance of his message. His red tower, about twenty-five-feet tall, stood in the urban park of the Toronto Sculpture Garden, which is surrounded by buildings. Built by a film-set construction company and installed by Macdonald as a disturbing urban monument, it was an exact replica in size and appearance of the very top portion of the CN Tower that rises about 1,815 feet above Toronto. In that city, where Macdonald used to live, the hyper-technological tower is one of the local tourist attractions. However, the portion of the tower reproduced cannot be visited; Macdonald thus brought this lofty place/object close to city dwellers, down to earth from its extreme heights.

But this is not a conciliating operation; his initial inspiration was the powerful image of the Statue of Liberty semi-submerged in sand, discovered by Charlton Heston's character at the end of *Planet of the Apes* (1968). This revelation crushed the desperate protagonist's belief that his interstellar voyage had brought him to an unknown planet in the future, while in fact the wild planet inhabited by speaking apes was none other than Earth, where human civilization vanished thousands of years ago. Thus we have to imagine that the CN Tower in Toronto today prefigures its destiny. Swallowed up by the earth through some cosmic catastrophe with

aber wenn man dieses Mikro-Ereignis betrachtet, kann man nicht umhin, an Sonnenfinsternis zu denken und an andere planetare Erscheinungen.

The Tower ist eine Freiluft-Skulptur, die Macdonald im Jahr 2004 geschaffen hat. Die visuelle Sprache, die anders ist, und die neuen Dimensionen dieser Arbeit ändern nichts an den Intentionen oder – was wesentlicher ist – an der Bedeutung seiner Botschaft. Der etwa 25 Fuß hohe rote Turm stand in einem städtischen Park, dem Skulptur-Garten Torontos, umgeben von Gebäuden. Macdonald schuf diesen Turm, den er von einer Film-Konstruktionsfirma errichten ließ, als ein beunruhigendes urbanes Monument. In Größe und Aussehen war der Turm eine exakte Replik der obersten Spitze des CN-Fernsehturmes, der sich 1815 Fuß hoch über die Stadt Toronto erhebt. In dieser Stadt, in der Macdonald vor Jahren als Halbwüchsiger gelebt hat, ist dieser hyper-technologische Turm eine lokale Touristen-Attraktion. Der oberste Abschnitt des Turmes, der hier reproduziert wurde, kann jedoch aus Sicherheitsgründen nicht besucht werden. Macdonald brachte dieses Objekt, diesen Ort, von seiner luftigen extremen Höhe herab und heran an die Stadtbewohner.

Dies ist aber nicht als ein konziliatorisches Unterfangen zu verstehen. Inspiriert wurde Macdonald vom Bild der mächtigen Freiheits-Statue, die fast gänzlich von Sand verschüttet, am Ende des Filmes *Planet der Affen* von der von Charlton Heston dargestellten Person gefunden wird (1968). Die Entdeckung dieser Statue macht den vermeintlichen Glauben des verzweifelten Protagonisten zunichte, seine interstellare Expedition habe ihn auf einen unbekannten Planeten und in die Zukunft transportiert. Der von sprechenden Affen bevölkerte, wilde Planet ist nichts anderes als der Planet Erde, von welchem alle menschliche Zivilisation tausende Jahre zuvor verschwunden ist. So müssen wir uns die Zukunft des CN-Fernsehturmes in Toronto vorstellen: Von der Erde während einer kosmischen Katastrophe verschluckt, ist nur noch seine oberste Spitze

- The Tower 2004
Wood, paint, and steel
1,5 x 7,4 m

only its spire left visible, it could be a find in the distant future.

I have said that Macdonald's work contains a socializing spirit that has nothing in common with the artist-guru, the prophet who wants to save our souls, putting angels and saints in galleries—perhaps with the help of Sony technicians. Quite the opposite, this artist needs only a puddle and a ball to have us think about the cosmos, or a tumbledown house along a river to have us grasp the infinite. Contemplating the most ephemeral details of the universe is a talent of great souls, and Macdonald measures himself against them, inviting us to do likewise.

Translated from Italian by Marguerite Shore.

sichtbar und könnte in ferner Zukunft zu einem Fundstück werden.

Macdonalds Arbeiten sind von einem sozialisierenden Geist getragen, der nichts gemein hat mit dem Künstler-Guru, dem Propheten, der unsere Seelen retten will, indem er Engel und Heilige in Galerien bringt – womöglich mit der Hilfe von Sony-Technikern. Ganz im Gegenteil: Dieser Künstler benötigt nur eine Pfütze und einen Ball, um uns über das Universum nachdenken zu lassen, oder ein abbruchreifes Haus an einem Flussufer, um uns ein Gefühl für Ewigkeit zu vermitteln. Über das Universum in seinen flüchtigsten Einzelheiten nachzudenken ist ein Talent der großen Denker. Macdonald misst sich mit ihnen und lädt uns ein, es ihm gleichzutun.

Aus dem Italienischen und Englischen übersetzt von Elisabeth Pozzi-Thanner.

the tower ¾ AP. FM

- The Tower 2004
 Silkscreen print
 40,5 x 48 cm

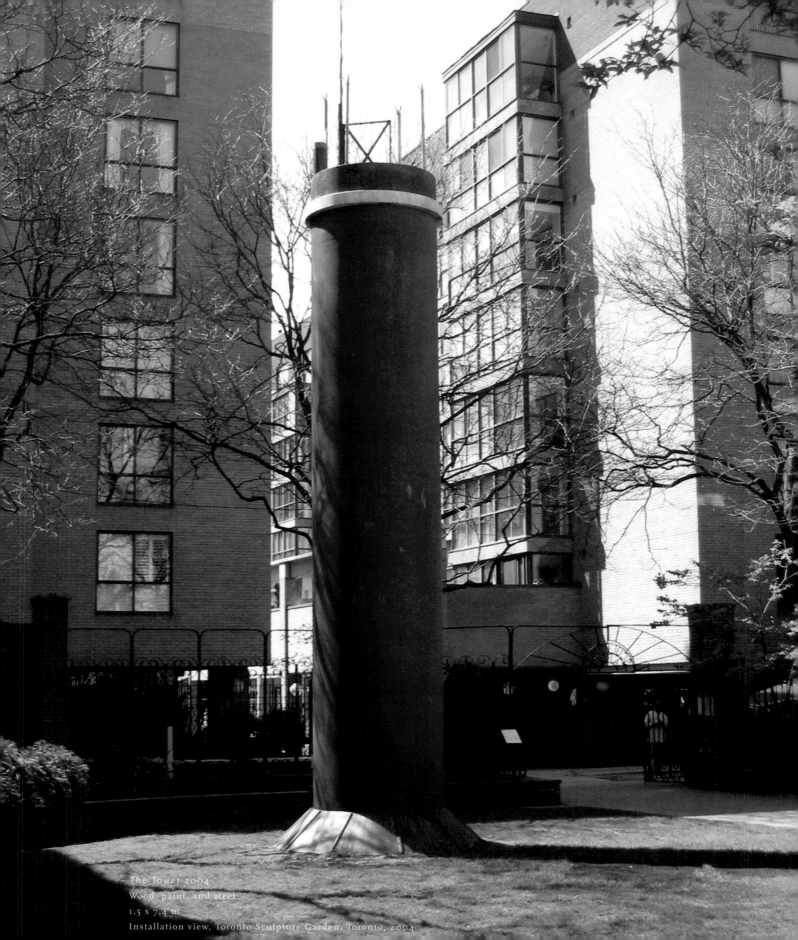

98

The Tower 2004
Wood, paint, and steel
1.5 x 7.4 m
Installation view, Toronto Sculpture Garden, Toronto, 2004

- Toronto skyline

- Statue of Liberty, in still from
 Planet of the Apes © 1968
 Twentieth Century Fox. All rights reserved.

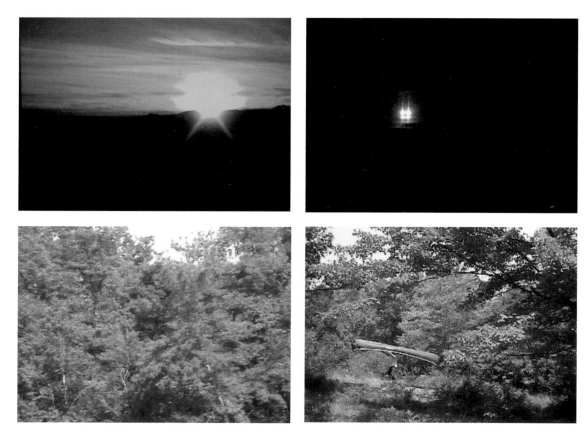

- Natura 2003
Single-channel video projection
3:33 minutes

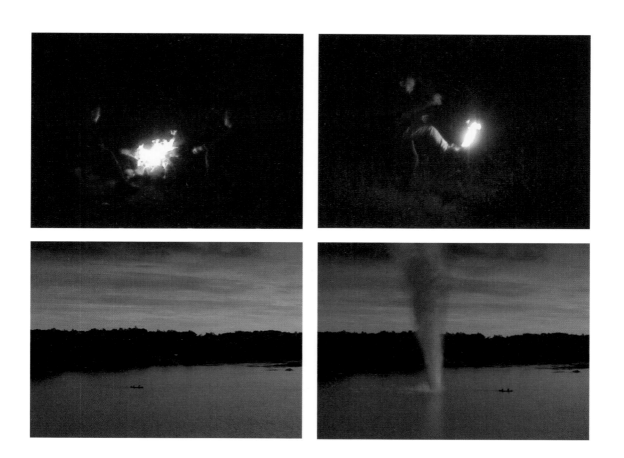

- Mysterioso 2003
Single-channel video projection
2:30 minutes

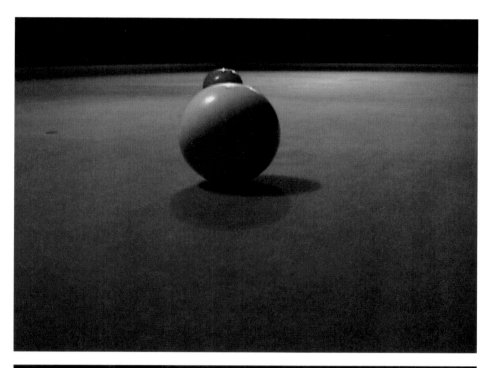

112

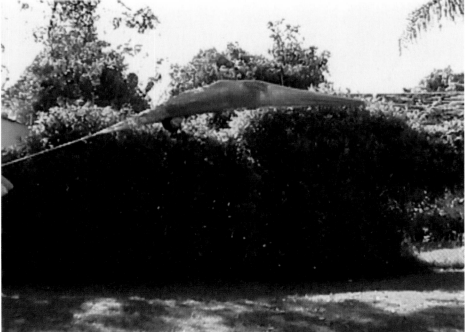

- Hammock 2000
 Single-channel video projection
 2 minutes

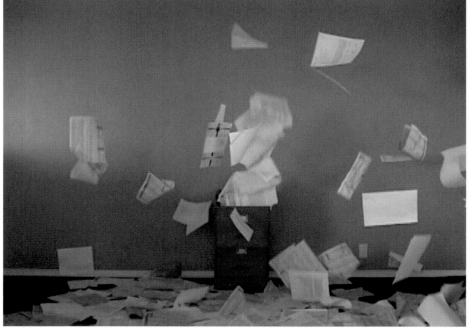

- File Cabinet 2004
 Single-channel video projection
 5 minutes

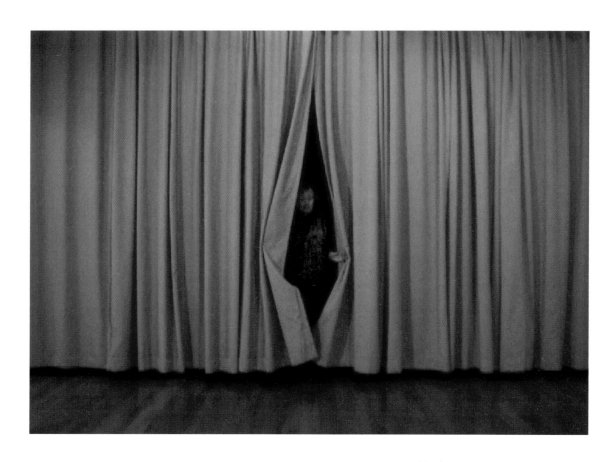

114

- Healer 2002
Single-channel video projection
5 minutes

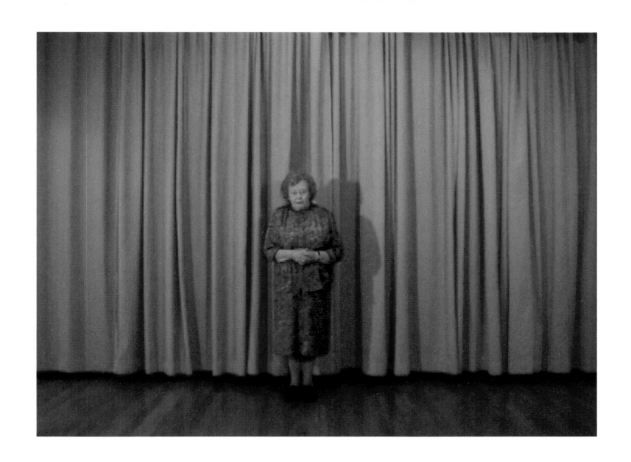

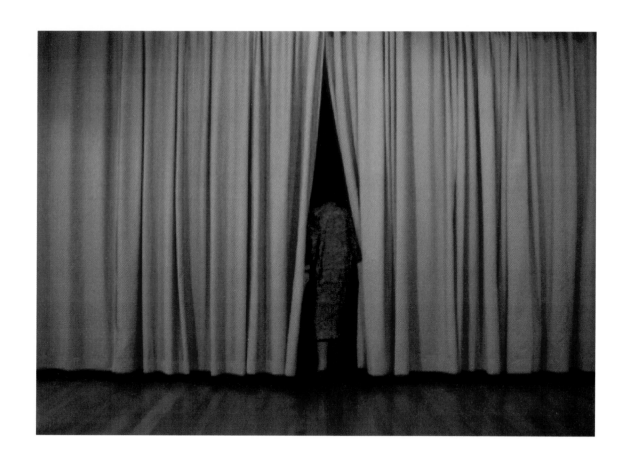

SELECTED SOLO EXHIBITIONS

2005
- Galleria S.A.L.E.S., Rome
- Darren Knight Gallery, Sydney, Australia
- *Two Places at Once*, Doris McCarthy Gallery, University of Toronto, Scarborough; and Black-wood Gallery, University of Toronto, Mississauga (curated by Barbara Fischer and Ann MacDonald)

2004
- *Eclipse, and Other Chance Appear-ances*, Kunstbunker, Nürnberg, Germany (curated by Hans-Jürgen Hafner)
- Cohan and Leslie, New York
- *The Tower*, Toronto Sculpture Garden, Toronto
- *Natura*, Jack Hanley Gallery, San Francisco

2003
- *Some Summer Day*, University Art Museum, California State University, Long Beach, California (curated by Mary-Kay Lombino)
- Jack Hanley Gallery, San Francisco
- Galerie Zink and Gegner, Munich, Germany
- Tracey Lawrence Gallery, Vancouver
- Robert Birch Gallery, Toronto

2002
- Cohan and Leslie, New York
- *Euan Macdonald: In the Shadow's Path*, Dunedin Public Art Gallery, Dunedin, New Zealand (curated by Justin Paton, exh. brochure)
- Darren Knight Gallery, Sydney, Australia
- Galleria S.A.L.E.S., Rome

2001
- *Same Universe*, James Van Damme Gallery, Brussels
- Jack Hanley Gallery, San Francisco
- Roberts & Tilton Gallery, Los Angeles

2000
- Shaheen Modern and Contemporary Art, Cleveland
- Galerie Zink, Munich, Germany
- Tracey Lawrence Gallery, Vancouver

1999
- Robert Birch Gallery, Toronto
- Four Walls, San Francisco
- *Euan Macdonald*, Southern Alberta Art Gallery, Lethbridge. Traveled to New Phase Art Space, Tainan, Taiwan; and Canadian Embassy Gallery, Tokyo

1998
- Or Gallery, Vancouver
- Oakville Galleries, Oakville, Ontario

1997
- *Present Tense*, Art Gallery of Ontario, Toronto

SELECTED GROUP EXHIBITIONS

2005
- *Seducidos por el accidente*, Fundación Luis Seoane, A Coruña, Spain (exh. cat.)
- *Irreducible: Contemporary Short Form Video*, Logan Galleries, CCA Wattis Institute for Contemporary Arts, San Francisco (curated by Ralph Rugoff, exh. cat.)
- *Still, Things Fall from the Sky*, California Museum of Photography, University of California, Riverside (curated by Ciara Ennis)
- *Togetherness*, Tracey Lawrence Gallery, Vancouver
- *L'Envers des apparences*, Musée d'art contemporain, Montréal (exh.cat.)

2004
- *Treble*, Sculpture Center, Long Island City, New York (curated by Regine Basha)
- *La alegría de mis sueños / The Joy of My Dreams*, Centro Andaluz de Arte Contemporáneo, Bienal Internacional de Arte Contemporáneo, Seville, Spain (curated by Harald Szeemann, exh. cat.)
- *2048 km*, Or Gallery, Vancouver (curated by Melanie Ward)
- *Dwellan: Contemporary Video Art*, Charlottenborg Exhibition Hall, Copenhagen (exh. cat.)
- *Friendly Fire*, Gus Fisher Gallery, Auckland, New Zealand
- *Break Away!*, Kelowna Art Gallery, Kelowna, British Columbia (curated by Linda Sawchyn)

2003
- *Adorno*, Kunstverein, Frankfurt, Germany (curated by Vanessa Joan Müller and Nicolaus Schafhausen, exh. cat.)
- *Defying Gravity: Contemporary Art and Flight*, North Carolina Museum of Art, Raleigh (exh. cat.)
- *Twilight Zone*, E-Werk: Hallen für Kunst, Freiburg, Germany
- *Rest Assured*, Center for Curatorial Studies, Bard College, Annandale-on-Hudson, New York (curated by Ana Vejzovic)
- *Without Fear and Reproach: Pulse of America*, Witte Zaal, Ghent, Belgium (curated by Jerome Jacobs)
- *Echo Sparks*, ARS Electronica Center, Linz, Austria
- Kunstbüro, Vienna
- *17 Reasons*, Jack Hanley Gallery, San Francisco (curated by Kate Fowle and Jack Hanley)
- *Friendly Fire*, Shed im Eisen-werk, Frauenfeld, Switzerland; and Pfalzgalerie, Kaiserslautern, Germany (curated by Leonhard Emmerling, exh. cat.)
- *Lautlos irren / Ways of World-making, Too*, Postbahnhof am Ostbahnhof, Berlin (curated by Harm Lux, exh. cat.)
- *Near Life Experience*, Anthony Wilkinson Gallery, London (curated by Claire Doherty)

117

- Sculpture Center, Long Island City, New York

2002
- *Gimme Shelter: Videos on Urban Discomfort*, Museo Tamayo Arts Contemporáneo, Mexico City (curated by Rita González)
- *Event Horizon*, Lothringer 13, Munich, Germany
- *The Gap Show: Young Critical Art from Great Britain*, Museum am Ostwall, Dortmund, Germany (exh. cat.)
- *Hammertown: Eight West Coast Canadian Artists*, The Fruitmarket Gallery, Edinburgh; Bluecoat Gallery, Liverpool, England; and Winnipeg Art Gallery, Ontario (curated by Reid Shier, exh. cat.)
- *Competitive Edges*, List Visual Arts Center, Massachusetts Institute of Technology, Cambridge, Massachusetts (curated by Bill Arning)
- Zero Arte Contemporanea, Milan, Italy
- *BANG: When Seeing Is Blinding*, Centre culturel canadien, Paris (curated by Eileen Sommerman, exh. cat.)
- *DV Noir: Video Art from Under the Shadow of Hollywood*, California Center for the Arts, Escondido, California
- *In Szene gesetzt: Architektur in der Fotografie der Gegenwart*, Museum für Neue Kunst, Karlsruhe, Germany; and Städtische Galerie, Erlangen, Germany (exh. cat.)

2001
- *Mayday, Mayday*, Swiss Institute, New York (curated by Marc-Olivier Wahler)
- Galerie Zink, Munich, Germany
- *Shelf Life*, Gasworks Gallery, London; and Blue Coat Gallery, Liverpool, England (curated by Smith + Fowle, exh. cat.)

- Galleria S.A.L.E.S., Rome
- *Orange Marble*, Hwa-shang Art District, Taipei (curated by Manray Hsu, exh. cat.)
- *010101: Art in Technological Times*, San Francisco Museum of Modern Art, San Francisco (exh. cat.)

2000
- *Too*, Platform, London
- *Three Day Weekend*, The Approach, London
- *Tout le temps / Every Time*, La Biennale, Montréal (curated by Peggy Gale, exh. cat.)
- *Almost*, The Living Room, Santa Monica, California (curated by Regine Basha, exh. brochure)
- *Fresh: The Altoids Curiously Strong Collection*, New Museum of Contemporary Art, New York; Nevada Institute of Contemporary Art, Las Vegas; The State Street Bridge Gallery, Chicago; Center Gallery, Miami-Dade Community College, Miami; The Luggage Store Gallery, San Francisco; and The Luckman Fine Arts Complex, California State University, Los Angeles

1999
- National Aviation Museum, Ottawa
- *The Time It Takes to Eat a Sandwich: Recent Video Art from Canada*, Depot: Kunst und Diskussion, Vienna
- Platform, London

SELECTED BIBLIOGRAPHY

- *Adorno: The Possibility of the Impossible.* 2 vols. Exh. cat. Frankfurt/Main, Germany: Kunstverein; and Berlin: Lukas & Sternberg, 2003. Texts by Norbert Bolz, Peter Bürger, Alex Demirovic, Diedrich Diederichsen, Alexander García Düttmann,

Isabelle Graw, Michael Hirsch, Christoph Menke, Georg Schöllhammer, Martin Seel, and Willem van Reijen.
- *La alegría de mis sueños / The Joy of My Dreams: Bienal Internacional de Arte Contemporáneo de Sevilla.* Exh. cat. Seville, Spain: Fundación BIACS, 2004. Texts by Juana de Aizpuru, Hans-Joachim Müller, and Harald Szeemann.
- André, Laura M. *Euan Macdonald.* In: *Defying Gravity: Contemporary Art and Flight.* Exh. cat. Raleigh, North Carolina: North Carolina Museum of Art, 2003.
- *Bang.* Exh. cat. Paris: Centre culturel canadien, 2002. Texts by Eileen Sommerman and Kika Thorne.
- Basha, Regine. *Almost.* Exh. brochure. Santa Monica, California: The Living Room, 2000.
- Berwick, Carly. *Euan Macdonald: Cohan and Leslie.* In: *Artnews* 103, no. 10 (November 2004): 155.
- Bishop, Janet. *Euan Macdonald.* In: *010101: Art in Technological Times*, 98–99. Exh. cat. San Francisco: San Francisco Museum of Modern Art, 2001.
- Braun, Alexander. *Euan Macdonald.* In: *The Gap Show: Junge zeitkritische Kunst aus Großbritannien*, 76–82. Exh. cat. Dortmund, Germany: Museum am Ostwall, 2002.
- Brennan, Stella. *Strangely Normal.* In: *Pavement*, no. 52 (April–May 2002).
- Chu, Ingrid. *Euan Macdonald: Robert Birch Gallery, Toronto.* In: *Frieze*, no. 50 (January–February 2000): 104.
- Cooper, Jacqueline. *Everything Happens at Once.* In: *Canadian Art* 18, no. 1 (spring 2001): 36–39.
- *L'Envers des apparences.* Exh. cat. Montréal: Musée d'art contemporain, 2005. Texts by Nathalie de Blois and Gilles Godmer.
- *Euan Macdonald.* Exh. cat. Leth-

bridge: Southern Alberta Art Gallery, 1999. Texts by Bill Arning, Hans Ulrich Obrist, Christina Ritchie, Gregory Salzman, and Joan Stebbins.
- Fowle, Kate. *Shelf Life*. In: *Shelf Life*, 34–41. Exh. cat. London: Gasworks Gallery, 2001.
- *Friendly Fire*. Exh. cat. Kaiserslautern, Germany: Pfalzgalerie, 2004. Texts by Britta E. Buhlmann and Leonhard Emmerling.
- Gale, Peggy. *Every Time*. In: *Tout le temps / Every Time: La Biennale de Montréal 2000*, 6–23. Exh. cat. Montréal: Centre international d'art contemporain, 2000.
- Gavaghan, Ann. *Motion in Stasis: Artistry with Little Happening*. In: *Taiwan News*, 15 October 1999, 6.
- Gilmore, Jonathan. *Euan Macdonald: Cohan Leslie and Browne*. In: *Tema Celeste*, no. 96 (March–April 2003): 90.
- Gopnik, Blake. *Artists Videos Give as Much Pleasure as Any Canvas*. In: *The Globe and Mail*, 14 January 1999, D3.
- Guaglianone, Pericle. *Euan Macdonald: S.A.L.E.S.* In: *Arte e Critica* (April 2005).
- Howard, Virginia. *Artists Brush Away Stereotypes*. In: *Ottawa Citizen*, 17 March 1996.
- Hsu, Manray. *Orange Marble*. Exh. cat. Taipei, 2001.
- Jordan, Betty Ann. *Euan Macdonald*. In: *The Globe and Mail*, 28 September 1996.
- Jordan, Betty Ann. *MUD*. In: *Canadian Art* (spring 1995).
- Knight, Christopher. *Art Reviews: Sweet Thrills*. In: *Los Angeles Times*, 26 January 2001, F27.
- Lacayo, Richard. *Euan Macdonald*. In: *Time Magazine* (Canadian edition) (14 October 2002).
- Lombino, Mary-Kay. *Endurance, Salvage and Entropy*. Exh. essay. Long Beach, California: University Art Museum, California State University, 2003.
- Martens, Anne. *Euan Macdonald:*

California University Art Museum, Long Beach. In: *Flash Art* (November–December 2003): 101.
- Massier, John. *A Spy in the House of Art*. Exh. essay. Toronto: Koffler Centre of the Arts, 1994.
- —. *Euan Macdonald*. Exh. brochure. Vancouver: Or Gallery, 1998.
- Meredith, Pamela. *Keep It Simple*. Exh. essay. Oakville, Ontario: Oakville Galleries, 1998.
- Miles, Christopher. *Euan Macdonald: Roberts & Tilton*. In: *Artforum* 39, no. 7 (March 2001): 149–50.
- Monk, Philip. *Euan Macdonald: Centennial Gallery, Oakville*. In: *Parachute*, no. 95 (July–September 1999): 47–48.
- Myers, Holly. *Crawling Through Time*. In: *Los Angeles Times*, 18 September 2003, E6.
- Paton, Justin. *You Are Here*. In: *Euan Macdonald: In the Shadow's Path*. Exh. brochure. Dunedin, New Zealand: Dunedin Public Art Gallery, 2002.
- Ritchie, Christina. *Based on a True Story*. Exh. brochure. Toronto: Art Gallery of Ontario, 1996.
- Rodney, Lee. *Still Life*. Exh. brochure. Toronto: Gallery 44 Centre for Contemporary Photography, 2000.
- Rugoff, Ralph. *File Cabinet*. In: *Irreducible: Contemporary Short Form Video*, 28. Exh. cat. San Francisco: CCA Wattis Institute for Contemporary Arts, 2005.
- Salzman, Gregory. *Euan Macdonald: Passive Aggressive*. In: *Canadian Art* 16, no. 2 (summer 1999): 80.
- *Seducidos por el accidente*. Exh. cat. A Coruña, Spain: Fundación Luis Seoane, 2005. Texts by Jean-François Chevrier, Fernando R. de la Flor, Benjamín González, Ignacio Ramonet, Alberto Ruiz de Samaniego, and Paul Virilio.
- Smith, Roberta. *At Shows Painted With Sound, Be Prepared to See With*

Your Ears. In: *The New York Times*, 21 May 2004.
- Taylor, Kate. *A Courageous Modesty*. In: *The Globe and Mail*, 12 May 1993.
- Tranberg, Dan. *Bending Time*. In: *Cleveland Free Times*, 1–7 November 2000.
- Turner, Michael. *This Land Is Your Land*. In: *Hammertown*, 8–23. Exh. cat. Edinburgh: The Fruitmarket Gallery; and Vancouver: Contemporary Art Gallery, 2002.
- Urban, Regina. *Der Ball im Wasser ist ein Mond*. In: *Nürnberger Zeitung*, May 2004.
- Verzotti, Giorgio. *Euan Macdonald: Galerie Zink & Gegner*. In: *Artforum* 42, no. 10 (summer 2004): 261–62.
- Williams, Alena. *Euan Macdonald: Roberts & Tilton*. In: *Tema Celeste*, no. 84 (March–April 2001): 8.

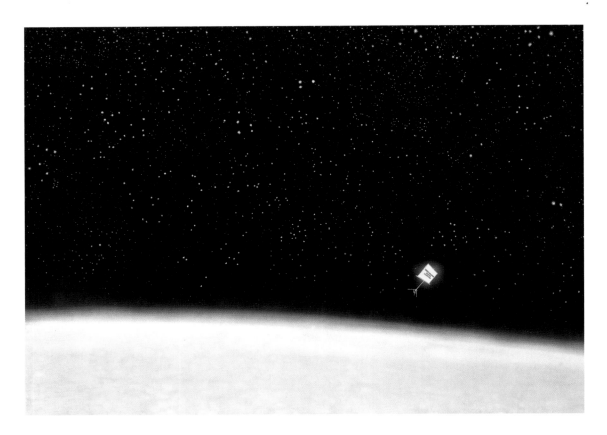

- Satellite 2005
Gouache on paper
101,5 x 76 cm

Sizes are given as width by height.
All images appear courtesy of the artist. The following,
keyed to page numbers, apply to images for which
separate credits are due.